American Art
of the 1960s

THE MUSEUM OF MODERN ART

NEW YORK

DISTRIBUTED BY HARRY N. ABRAMS, INC., NEW YORK

Publication of *Studies in Modern Art* is funded for three years by a grant from the Andrew W. Mellon Foundation. Future issues will be supported in part by an endowment fund established by the Andrew W. Mellon Foundation, the Edward John Noble Foundation, and the National Endowment for the Humanities' Challenge Grant Program.

Studies in Modern Art, no. 1
Copyright © 1991 by The Museum of Modern Art, New York
"Overcoming the Limits of Matter: On Revising Minimalism"
copyright © 1991 by Rosalind Krauss
Certain illustrations are covered by claims to copyright noted with the Photograph Credits, p. 182.
All rights reserved
Library of Congress Catalog Card Number 91-61564
ISBN 0-87070-458-3 (The Museum of Modern Art, paperback)
ISBN 0-87070-180-0 (The Museum of Modern Art, hardcover)
ISBN 0-8109-6099-0 (Harry N. Abrams, Inc., hardcover)
ISSN 1058-997X

Produced by the Department of Publications
The Museum of Modern Art, New York
Osa Brown, Director of Publications

Edited by James Leggio and Susan Weiley
Design and typography by Michael Hentges
Production by Vicki Drake
Printing and color separations by Princeton Polychrome Press, Princeton, New Jersey
Bound by The Riverside Group, Rochester, New York

Published annually by The Museum of Modern Art,
11 West 53 Street, New York, New York 10019

Hardcover edition distributed in the United States and Canada
by Harry N. Abrams, Inc., New York, A Times Mirror Company

Hardcover edition distributed outside the United States and Canada
by Thames and Hudson Ltd., London

Cover: Carl Andre. *144 Lead Square* (detail of fig. 10, p. 27)

Contents

Foreword **6**
Richard E. Oldenburg

Preface **9**
John Elderfield

Ad Reinhardt and the Younger Artists of the 1960s **16**
Lynn Zelevansky

Jasper Johns: Ale Cans and Art **39**
Wendy Weitman

The Precursor **65**
John Elderfield

Jim Dine and Performance **97**
Joseph Ruzicka

Overcoming the Limits of Matter:
On Revising Minimalism **123**
Rosalind Krauss

Complexity and Contradiction Twenty-five Years Later:
An Interview with Robert Venturi **142**
Stuart Wrede

Elia Kazan's *Wild River* **165**
Charles Silver

Contributors **182**

Index of Illustrations **184**

Foreword

In early 1989, Neil L. Rudenstine, then the Executive Vice President of the Andrew W. Mellon Foundation, discussed with me and other museum colleagues a grant program the Foundation was developing. Visionary in scope, it was intended to reinvigorate scholarly interest in the permanent collections of museums, a sadly neglected area of study in recent decades. At the same time, the program was to be based on a pragmatic recognition that the day-to-day administrative duties of museum work often make it difficult for curators and other museum professionals to find time to undertake research or to write. This initiative was most welcome and opportune, not only at The Museum of Modern Art, but in the museum community at large. With the sharply rising costs of large-scale loan exhibitions, and the investment of staff hours they also require, museums across the country have been seeking effective ways to devote more of their resources to the study and exposition of their permanent holdings. The Mellon Foundation's initiative helps to meet this need by establishing grants for programs — each tailored to the individual needs of participating institutions — that allow staff to spend more of their time on collection-related activities, the work for which they have been trained and have primary responsibility.

After much deliberation within the Museum regarding how such a project might best be structured at this institution, it was decided to establish the Research and Scholarly Publications Program, which, as one of its principal endeavors, would publish a scholarly journal, *Studies in Modern Art*. This journal, the chief means through which the fruits of the program's research are to be published, is presently the only scholarly, noncommercial journal dedicated to modern and contemporary art. Each issue is expected to focus on a selected topic: in the case of this inaugural issue, American art of the 1960s. Staff members from all six curatorial departments, as well as from Conservation, the Library, the Archives, Education, Exhibitions, and administrative departments, are encouraged to contribute to the journal; when appropriate, distinguished outside scholars are also invited to participate.

Staff contributors have available to them various kinds of research support, such as travel funds, research assistance, and time away from their

regular duties to concentrate on scholarly pursuits. Such active and pragmatic encouragement of research and publishing by museum staff is rare in the field and firmly reinforces the Museum's longstanding commitment to art scholarship.

John Elderfield, Director of the Department of Drawings and Curator in the Department of Painting and Sculpture, has assumed the burden of the program's administrative responsibilities and acts as Editor of *Studies in Modern Art*. With his customary diplomacy and his critical intelligence, he has guided the project through its formative stages to this, its first tangible result. He has been ably assisted in the day-to-day work on the journal by Joseph Ruzicka, Research Coordinator of the project, and James Leggio, Editor in the Department of Publications. These three, along with John Szarkowski, Director of the Department of Photography until his retirement in 1991, and Kirk Varnedoe, Director of the Department of Painting and Sculpture, constituted the Editorial Committee for this issue and were primarily responsible for developing its contents. In addition, an Advisory Committee addressed the Museum-wide questions that a project of this scope inevitably raised. The Advisory Committee is composed principally of the directors of Museum departments; besides those already named it includes: Mary Lea Bandy, Director of the Department of Film; Osa Brown, Director of the Department of Publications; Riva Castleman, Director of the Department of Prints and Illustrated Books, and Deputy Director for Curatorial Affairs; Antoinette King, Director of the Department of Conservation; Richard L. Palmer, Coordinator of the Exhibition Program; Clive Phillpot, Director of the Library; Waldo Rasmussen, Director of the International Program; Beverly M. Wolff, Secretary and General Counsel; Stuart Wrede, Director of the Department of Architecture and Design; and Philip Yenawine, Director of the Department of Education. Many other individuals in various departments of the Museum have generously contributed time and thought to aspects of the program. Indeed, one of the emerging benefits of the journal is the fostering of greater collaboration and cooperation among departments of the Museum, expanding opportunities for intellectual exchange.

Establishing a strong financial base for a program of this magnitude required very generous support from several sources, to whom we are deeply grateful. The Andrew W. Mellon Foundation's initial grant was intended to cover costs of the program for its first three years, and, with typical foresight, the Foundation also established a challenge grant toward an endowment to support the project in subsequent years. The Edward John Noble Foundation, which has a distinguished record of furthering art education and scholarship, responded to the Mellon Foundation's challenge by making an equally substantial gift. The National Endowment for the Humanities also recognized the important purposes of this program and awarded a major

grant, which is most appreciated. Such strong support for the research pro-
gram before the appearance of the first issue of *Studies in Modern Art* has
been enormously encouraging, and reflects the confidence inspired by the
Museum's continuing dedication to the highest standards of art-historical
scholarship.

 In conclusion, I should like to express my special thanks to the
Andrew W. Mellon Foundation, to its President and trustees, to its knowl-
edgeable staff, and to Neil Rudenstine, for their sensitivity to changing needs
in the museum profession and their concern to address them imaginatively. I
also wish to note again the gratitude and admiration due John Elderfield. It
is his good judgment, connoisseurship, and full commitment, despite many
other demands on his time, which have shaped and guided this program and
given it every prospect of a productive future.

 Richard E. Oldenburg
 Director
 The Museum of Modern Art

Preface

Studies in Modern Art is the creation of two convergent motivations, one longstanding and one immediate. For many years, a consensus had been developing at The Museum of Modern Art that a vehicle should be found to foster scholarship and publication based on the extraordinary riches of our collection as well as on the individual research interests of the Museum's curators and other members of its staff. Such scholarship and publication took place, but not as consistently as we wished, in part owing to the demands and enforced deadlines of loan exhibitions, and in part because there was no formally established program to encourage it. The recent offer of support from the Andrew W. Mellon Foundation, subsequently complemented by the Edward John Noble Foundation and the National Endowment for the Humanities, helped us to clarify and to consolidate our ideas for enhancing scholarly work at the Museum. This publication is the first result.

In the earlier history of the Museum, for some thirty years, from 1933 through 1963, there was a publication titled *Bulletin of The Museum of Modern Art* which, among its other functions, presented articles about works in the collection. However, it eventually began to serve as a surrogate exhibition catalogue and as a very inadequate vehicle for introducing recent acquisitions. Over the years, its frequency declined from a thriving nine issues per year to a sluggish three. Its informational functions have now been taken over by a calendar of events and by the quarterly, *MoMA*, distributed by the Museum to its members.

While the *Bulletin* was declining, a proposal was made by the Museum's Publications Committee that there be issued a regular "journal of criticism and commentary on all of the arts represented in the Museum's program" that would become "a forum for the objective discussion of ideas closely associated with the Museum's activities, as well as for marginal material of special interest." It would contain articles mainly by staff members but also by outside contributors and "would apply professional standards of criticism and scholarship to the arts of the twentieth century."[1] Nothing came of the idea. The Museum's short-lived International Study Center, which in the years around 1970 gave visiting scholars special access to our research facili-

ties, was an inspired way of facilitating study of our collections and of twenti-eth-century art in general as well as of encouraging intellectual interchange between the Museum's curators and the broader scholarly community. It anticipated some of the functions of our new Research and Scholarly Publications Program, which issues *Studies in Modern Art.* Unfortunately, it was ahead of its time and proved impossible to sustain.

In the absence of an established program or vehicle for research and scholarly publications, these activities nevertheless have been pursued within the individual Museum departments. From the detailed critical catalogues on our important holdings of Matisse, Miró, and Picasso (with a volume on Dubuffet to follow next) to a series of acclaimed books on the works of Atget in our collection, and from the basic checklist catalogues issued or in prepara-tion by a number of our departments to the publications that accompany major groups of gifts or bequests or that record selected masterworks in vari-ous mediums, we have been slowly advancing understanding of the works of art in our care. Recently, the Museum's Archives were formally established to provide a resource for scholarly research. These, together with the Museum's Library and the records maintained by the curatorial and support depart-ments, give us an extraordinary collection of primary and secondary refer-ence material on this century's art.

And yet, much remains to be done. The essential aim of our new Research and Scholarly Publications Program is to help to make research and publication on works in the collection and on topics relating to it an integral and feasible part of the duties of curators and other Museum professionals. The majority by far of the research and writing undertaken at The Museum of Modern Art is produced on the occasion of loan exhibitions and is devoted largely to borrowed works. These exhibitions and their associated scholarship do enlarge understanding of the Museum's collection; because they study sub-jects that are inevitably represented in some way in the collection, they show in depth what the collection shows in part. But direct focus on the collection is still needed. The holdings of The Museum of Modern Art are widely acknowledged to be without parallel, in both scope and importance, among collections of modern art. However, as the Museum's first director, Alfred H. Barr, Jr., observed as early as 1944, arguing for collections research, "Whether the work of art subsequently lives or dies depends partly on its intrinsic quali-ties, partly on the attention we are able to give it by our continued interest."[2] Many are the works of art in the collection Barr founded that await the atten-tion they deserve.

Studies in Modern Art thus seeks to sustain the Museum's collection: by detailed study of individual works and groups of works; by broader exami-nation of those works in a variety of contexts; from consideration of the Museum's own programs and own history; through publication of documents from the Museum's as yet nearly unexplored Archives; through recording lec-

ture series and symposia on themes related to the collection. At times, a volume will serve as the accompanying publication for an exhibition based exclusively or closely on the collection. At others, a volume will collect essays written after an important exhibition that contains at least a core of material from the Museum. But mainly, it will be independent of temporary exhibitions, seeking to attract scholarly attention to the collection of the Museum in its six curatorial departments — Painting and Sculpture, Drawings, Prints and Illustrated Books, Architecture and Design, Photography, and Film — by encouraging research from within these departments; from, additionally, the departments of Conservation and Education, the Museum's International and Exhibitions Programs, Library, Archives, and Administration; and from any scholar interested in the collection or programs of the Museum. We will be particularly interested in previously unexamined topics, whether in contemporary or earlier modern art, and in works of art to which little attention has been paid. But we will continue to revisit even the most celebrated of our holdings, for even they will be diminished unless renewed attention is devoted to them from time to time.

In founding *Studies in Modern Art*, it was our aim that each volume should have a unifying theme; this would help to focus research within the Museum and would result in a useful work of reference on that subject, and specifically on the Museum's response to it. But additionally, we decided that wherever possible the unifying theme of each volume would be developed to elicit potential contributions from all the curatorial and the support departments within the Museum. Thus, for example, examination of selected periods or movements of modern art, as well as important conceptual or technical ideas, could serve to bring together curators from different departments and other professionals to foster scholarly discussion. We do not preclude volumes on narrowly defined themes, among them themes that might appear to curb our ecumenicism. Indeed, we plan to produce volumes even on individual works of art, viewing projects of this kind as another way of enlarging our scholarly forum by opening it to specialists outside the Museum. Our wish to create new contacts and collaborations between the Museum and the broader scholarly community is such that we will welcome external as well as internal proposals for contributions at any time. As a matter of principle we intend, wherever possible, to publish at least one distinguished contribution from outside the Museum in each volume. But the more specialized the volume, the more we will depend on the good will of our colleagues in the art-historical community at large.

The first issue of our publication is devoted to American art of the 1960s. It addresses a very broad range of topics in this area, from a neglected film and a surprising exhibition to a renowned series of prints and a most influential painter. It does not pretend to cover comprehensively the art of this decade or

the Museum's response to it. I doubt if any single volume could. In any case, comprehensiveness is not the aim of our publication. Its aim, rather, is to present original research and insightful writing, most of it by members of the Museum's staff, on illuminating topics within its chosen area. We believe that each of the contributions to this volume offers new understanding of its subject. We hope that together, with their varied interests and through their different voices, they will afford a sense of the diversity and richness of a fascinating decade.

We chose American art of the 1960s as the focus of this issue because it was the kind of subject that could encourage the interest of a broad range of contributions, and we are pleased that this has proven to be the case. Our seven contributions are from six Museum staff members, each from a different department, and one outside scholar. But we also chose this subject for other reasons: most important, that our collection has an abundance of works from this decade and the quality of many of them is high. Additionally, however, this decade seemed simply most requiring of attention in this first issue. The period of the 1960s was crucial in the creation of art in America as it appears today. The period was also crucial in the Museum's own history; during the 1960s, it now seems, took place the most important of the changes that transformed it from the institution founded in 1929 to the one that exists today. This period of transition is still in the process of both critical and creative reassessment, attracting keen interest both from historians and critics and from younger artists. Yet it is about to settle into history; the Museum has just dedicated permanent gallery spaces to this period for the first time. Therefore, now is the moment to offer this reconsideration of the 1960s, and to hope that further and more far-reaching reconsideration will follow.

There was a final reason for choosing this subject: we wished to signal our determination to extend the Museum's existing record of scholarship, which has tended to focus on earlier periods, into more recent art. It used to be said there was a moment at which the work of the critic gave way to, or made room for, the work of the historian. The concurrent development of the discipline of art history and of modern art itself has meant that the latter is delivered into the waiting arms of the former; modern art is more immediately lodged in history than any earlier art has been. And yet, as before, the historical understanding of art does not come immediately with it, but requires the distance that scholarship, more even than time, provides. We will encourage such art-historical scholarship for recent as well as for more distant art, and not only for the sake of purely historical understanding but also because it can foster critical understanding at the same time. Immunity from critical assessment may be sought in historical study. But so may more balanced critical assessment than practical criticism allows.

A range of approaches across these options characterizes the contributions to the present volume, which additionally roam widely and with vary-

ing degrees of specificity around its chosen theme, some managing to inter-connect with each other just the same. Lynn Zelevansky argues that the work of Ad Reinhardt, by its suppression of the act of marking the surface and its reductionist approach to composition and color, is a crucial bridge between Abstract Expressionism and Minimalism. That same transition is very differently explored in my own study, developed around the Museum's Turner exhibition of 1966, of how changing attitudes toward earlier painting on the part of artists and critics in the 1960s informed and were informed by their attitudes toward contemporary painting. And it opens the article by Rosalind Krauss, the invited contributor from outside the Museum, who examines the sharply differing attitudes toward the physicality of art objects in Minimalism and in California light-and-space art.

Unfamiliar works by well-known artists are the subjects of two articles. Charles Silver reassesses Elia Kazan's neglected masterpiece, *Wild River* of 1960, viewing this lyrical romance, set in the New Deal era, as a rare example of an American film seriously confronting issues of social and political change. And Joseph Ruzicka traces Jim Dine's work in the performing arts from his Happenings of the earlier 1960s through his 1967–68 adaptation of Oscar Wilde's *The Picture of Dorian Gray*, intended for the London stage, considering his drawings and designs in the Museum's collection. The working proofs for Jasper Johns's 1964 lithograph *Ale Cans* are the principal subject of Wendy Weitman's article. She deciphers the artist's transformations of his sculpture *Painted Bronze* into two-dimensional images. And aspects of the 1960s are summarized and placed in historical context in the remaining contribution. Stuart Wrede interviews Robert Venturi about the genesis and the impact of Mr. Venturi's influential book *Complexity and Contradiction in Architecture*. Published by the Museum in 1966, it helped to usher in what became known as postmodernism.

Many people were involved in the deliberations that led to the Research and Scholarly Publications Program. The endeavor was initiated by Richard E. Oldenburg, Director of The Museum of Modern Art, whose enthusiasm for and support of this program have been vital. All of the Museum's curatorial department heads played an active role in determining the scope of the program. Additionally, they agreed to serve with other, noncuratorial department heads, on its Advisory Committee. All the members of the committee are named in the Director's Foreword; I thank them most sincerely for their counsel and their encouragement. The Museum's Deputy Director for Development and Public Affairs, Sue B. Dorn, and its Director of Development, Daniel Vecchitto, were indispensable to the foundation of the program; Osa Brown, Director of Publications, to the realization of the publication.

To my colleagues on the Editorial Committee go my particular thanks. Joseph Ruzicka, Research Coordinator of the project, and James

Leggio, Editor in the Department of Publications, are with me its permanent members and have been deeply involved not only with the production of this volume but with establishing the very nature of the research program and the format of the publication itself. The two other members of the Editorial Committee are appointed specifically for a particular issue of the publication. John Szarkowski, Director of the Department of Photography until his retirement in 1991, and Kirk Varnedoe, Director of the Department of Painting and Sculpture, generously found the time to serve for this first and consequently very demanding issue. Thanks are owing also to Michael Hentges, the Museum's Director of Graphics, for working with us so assiduously and creatively on the design of the publication; to Vicki Drake, for overseeing its production and printing; to Susan Weiley, for her editorial participation; to Catherine Truman, for her secretarial support; to Jennifer Hersh, for her research assistance; and to Kevin Robbins, Assistant to the Director, Department of Drawings, for assuming the additional duties my direction of this program entailed. We are deeply indebted to the anonymous outside readers who evaluated each contribution, often offering important criticism and advice. And of course, most important, we are indebted to the authors themselves; on their shoulders rests the responsibility for the success of this enterprise as a whole. We know that it is not easy for those with already busy schedules to undertake additional obligations of this kind. However, we know that the Museum's scholarly stature depends very crucially upon their willingness to do so. Publications remain after exhibitions disappear.

Finally, and of immediate relevance to this, we wish to remember on the present occasion a close friend of the Museum, Sir Lawrence Gowing, who contributed in 1966 the first of a series of brilliant essays for this museum's publications; who died as this volume was in preparation; and whose example is a beacon to us all.

John Elderfield
Editor
Studies in Modern Art

Notes

1. "Subcommittee Report on the Proposed Journal of The Museum of Modern Art," unsigned and undated (late 1950s?). The Alfred H. Barr, Jr., Papers. Archives of The Museum of Modern Art.

2. "Research and Publications in Art Museums," transcript of a paper read at a conference on "The Future of the Art Museum as an Educational Institution," held in Chicago, March 24–25, 1944, published in *Museum News*, 23 (January 1, 1946), p. 8; reprinted in *Defining Modern Art: Selected Writings of Alfred H. Barr, Jr.*, ed. Irving Sandler and Amy Newman (New York: Harry N. Abrams, 1988), p. 209.

A Note to Contributors

Studies in Modern Art publishes scholarly articles focusing on works of art in the collection of The Museum of Modern Art and on topics related to the Museum's programs. It is issued annually, although additional special numbers may be published from time to time. Each number deals with a particular theme related to the Museum's collection or programs. A list of future topics may be obtained from the journal office.

Contributors should submit proposals to the Editorial Committee of the journal by February 1 of the year preceding publication. Proposals should include the title of the article; a 500-word description of the topic; a critical appraisal of the current state of scholarship on the subject; and a list of works in the Museum's collection or details of the Museum's program that will be discussed. A working draft of the article may be submitted as a proposal. The Editorial Committee will evaluate all proposals and invite selected authors to submit finished manuscripts. (Such an invitation does not constitute acceptance of the article for publication.) Authors of articles published in the journal receive an honorarium and complimentary copies of the issue.

Please address all inquiries to:

Studies in Modern Art
The Museum of Modern Art
11 West 53 Street
New York, New York 10019

Ad Reinhardt and the Younger Artists of the 1960s

Lynn Zelevansky

Ad Reinhardt's role in the development of American art of the 1960s has been both underestimated and overestimated, but it has never truly been examined in depth. An active if dissident member of the Abstract Expressionist circle, Reinhardt had subsequently followed a course independent of Abstract Expressionist concerns during the 1950s, with the result that, by the beginning of the sixties, his paintings appeared peripheral to mainstream art discourse. His work therefore received less attention than that of many of his New York School colleagues.[1] But as early as 1963 he was seen as a progenitor of what was soon to become known as Minimalism.[2] And by 1965 or 1966, Reinhardt's generative impact on it was touted to such an extent that even some sympathetic critics felt the need to counter this notion with a disclaimer, arguing that he had had no "direct" impact on the Minimalist aesthetic.[3]

The new "cool," "minimal," or "rejective" art — to cite just a few of its early names — had begun to emerge within the art world at the start of the 1960s. Although the artists involved did not share a body of beliefs or constitute a movement as such, they did share a disillusionment with what they saw as the emotional excesses of Abstract Expressionism. They sought an escape from the emphasis on subjective experience reflected in the theoretically "autobiographical," markedly painterly styles of the New York School, and deliberately downplayed the spiritual or psychological aspects of art. Focusing instead on the material qualities of the object, they favored reductive forms that they felt limited the possibilities for metaphorical interpretation.

Most frequently, these artists worked in three dimensions as a means of making the "concrete and literal" dominant in their work and avoiding the inherent illusionism of painting.[4] Donald Judd and Robert Morris are obvious examples of this approach, as is Robert Smithson, who, by the middle of the decade, had found in the regular, geometric structure of crystals a way of dealing with nature without the aid of biological metaphors.[5] Those who continued to paint, like Jo Baer, grappled with the medium's intransigent illusionism, generally opting for a smoother, relatively undifferentiated facture, less obviously indicative of a particular sensibility or temperament.[6] They often attempted to reduce the emotional thrust of color with palettes that

1. Ad Reinhardt. *Abstract Painting, 1957, 108 x 40"*. 1957. Oil on canvas, 9' x 40" (274.3 x 101.6 cm). The Museum of Modern Art, New York. Purchase

tended toward monochromy or, like Robert Mangold, by utilizing "generic or 'industrial' colors."[7] Artists such as Sol LeWitt and Carl Andre based their work on personal systems or guidelines that employed fundamental organizational elements like the grid and the module, frameworks that ensured a kind of objectivity in the final product. In camouflaging the individual brushstroke, or in having three-dimensional works manufactured by outside contractors, Jo Baer and Donald Judd downgraded the role of "touch," the significance of the artist's hand in the fabrication of the art work.

Although Reinhardt anticipated the Minimalist program more than any artist of his generation, he was not a Minimalist. His efforts to obliterate all extra-artistic meaning from his painting, as well as his use of rigorous geometry and standardized formats, did constitute a decisive break with Abstract Expressionism. But the poetry of his delicately nuanced surfaces and the contemplative character of his work tied it nonetheless to an earlier aesthetic, and were antithetical to the spirit of Minimalism.

Within the art world, a wider understanding of Reinhardt's contribution was almost certainly hampered by the fact that his painting was not classifiable within a category or movement then considered viable. It was probably also hindered by the artist's attempt, in what he termed his "ultimate" paintings of the 1960s, to achieve a kind of closure. The word "ultimate" would seem to refer to the last, or the most extreme, in a line. Though Reinhardt's use of the term was always ambivalent and satirical, critics and younger artists most often have interpreted him to mean that he was making the last paintings that could be made.[8] Reinhardt knew, of course, that this was not literally the case (his work did not herald the end of easel painting, even if, in the sixties and seventies, some thought this form was "dead"), but he does seem to have believed his work was the most extreme example of a particular tradition, that of purist abstract painting. If he was correct, then even in this second sense of "ultimate," his black squares should allow for no direct descendants.

Nonetheless, Reinhardt's art and ideas had a powerful impact on certain artists who, like Sol LeWitt and Carl Andre, were to become highly influential themselves. By adopting isolated formal and conceptual aspects of Reinhardt's work, rather than its look, these artists were able to pursue a variety of new directions.

The Black Square Paintings

By 1960, around the time the new generation began appearing on the New York scene, Ad Reinhardt had started to make the 60-by-60-inch "black" paintings that would occupy him almost exclusively until his death, in 1967. In 1952, he had begun making geometrically composed, symmetrical, monochrome paintings in either red or blue. In 1954, he reduced his palette to shades of black. With the further reduction of variables — the adoption,

ected black surfaces. Painting at its most essential, these works must be experienced directly, as they defy even the most rudimentary representation in any other visual medium.

In his published statements, lectures, and interviews, Reinhardt often exaggerated the characteristics of his painting, partly for satirical effect, since he was generally commenting on prevalent ideas about his art and art in general, but also in order to emphasize the radical nature of his goals. In so doing, he implicitly underscored the paradoxical nature of his enterprise, for his writings tended to present as absolute and unmitigated those very characteristics that remain most equivocal in his art. Indeed, the most dominant characteristic of the paintings is how they defy definition. Contrary to what Reinhardt wrote about the black squares, they were not "ultimate," since he in fact continued painting them; they are not really "black"; they are not "lightless" or "colorless"; they are not "formless"; and they are not "timeless," since they can be located at a specific moment within the development of a given tradition. In addition, in the passage quoted above, Reinhardt's use of metaphorical language, especially personification, for a work that is supposed to be "neutral" and without worldly associations, is particularly paradoxical. But contradiction and inconsistency stress the impossibility of perfection even as the artist strives for it, deepening rather than lessening the impact of the work.

Reinhardt was careful not to claim any sort of historical precedence in relation to Minimalism,[30] but he must have known that, in striving toward a reductionist kind of perfection (an "absolute"), he had struck a chord with the next generation. He was aware as well that, for many younger artists, the physical or optical effort required to actually "see" his paintings, as well as the effort necessary to draw meaning from them, were significant factors. Reinhardt said of the Minimalists, "They may be making large paintings, too large for museums. My making a painting that can't be seen may be like making a work too large to move in and out of places."[31] He was acknowledging a shared "resistance" to established and expected practice, accessibility, and acceptability. Like their art, his was "difficult," and carried with it a built-in test of the commitment of the audience.[32]

LeWitt says that, either consciously or unconsciously (he is unsure which), the idea of making the lines quite faint in his wall drawings originated with Reinhardt's difficult-to-see black squares. Tired of the bombast associated with Abstract Expressionism, even with work he respected — "You could see a Franz Kline painting from a half a mile away"[33] — he was searching for another model. In truth, a Reinhardt black square can be identified from the same distance as a Kline, and Abstract Expressionist paintings generally need to be approached and studied to be fully appreciated. Nevertheless, the extreme subtlety that is the essence of Reinhardt's art requires that viewers inspect his paintings especially closely in order even to discern their configu-

7. Ad Reinhardt. *Abstract Painting.* 1963.
Oil on canvas, 60 x 60" (152.4 x 152.4 cm).
The Museum of Modern Art, New York.
Gift of Mrs. Morton J. Hornick

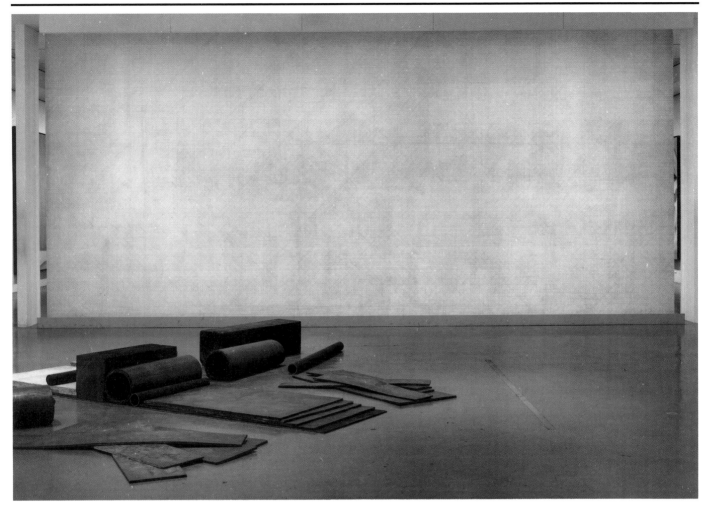

rations. LeWitt took this idea a step further: from far away, a wall drawing like *Straight Lines in Four Directions Superimposed* of 1969 (fig. 8) does not even appear to be art. As with his first lattice sculptures, LeWitt's earliest wall drawings were monochrome black. This one is to be executed in graphite. Viewed from a distance, the light pencil marks meld with their environment, blending together to resemble a plain gray wall.

Like Reinhardt's *Abstract Painting,* LeWitt's *Straight Lines in Four Directions Superimposed* has a kind of reticence,[34] an immateriality, an almost phantom imagery. (The drawing is phantom-like in more ways than one, since it exists only as a set of instructions, except when it is installed, and is of varying dimensions, depending on the size of the wall used as a support.) It also makes use of an important aspect of Reinhardt's legacy, the idea of built-in "duration," born of the fact that it takes some minutes for the eye to attune itself to the blackness of one of the square paintings, to be able to actually "see" into it. As with the Reinhardt, one must not only physically approach *Straight Lines in Four Directions Superimposed,* but also spend time with it, in order to perceive its subtle geometry.

8. Sol LeWitt. *Straight Lines in Four Directions Superimposed.* 1969. (Vertical, horizontal, 45° diagonal left and right lines drawn as close together as possible, approximately ¹/₁₆" apart.) Graphite on white wall, size variable. The Museum of Modern Art, New York. Anonymous fund in honor of Mr. and Mrs. Alfred H. Barr, Jr. In foreground: Richard Serra, *Cutting Device: Base Plate Measure,* 1969 (The Museum of Modern Art, New York)

Like LeWitt, Carl Andre was intrigued by the outright effort required to perceive and understand Reinhardt's black paintings. In 1960, Andre lived with a black Reinhardt that was owned by Frank Stella, an experience that left its mark: "It was while trying to see Ad's black paintings that I fully realized that it requires work to see any work of art."[35] Andre states that Reinhardt was "quite an influence," and that it was through Reinhardt's black paintings that the idea came about of having the spectator work to "recover the nature of painting."[36]

Andre transformed Reinhardt's idea, making sculptures that are difficult to see not because they are almost imperceptible, but because they do not announce themselves as art: "I don't want to make works that hit you over the head or smash you in the eye. I like works that you can be in a room with and ignore when you want to ignore them."[37] The small sculpture *Timber Spindle Exercise* of 1964 (fig. 9), a simple form made of uncarved wood, which stands less than three feet high, is prosaic-looking and unobtrusive enough to be easily overlooked, not "seen" as art.

It is with the almost flat, metal floor pieces that Andre's extrapolation from Reinhardt's black squares can be most clearly understood. A work like *144 Lead Square* of 1969 (fig. 10) shares the predominance of the grid. It is intended, in its own way, to be as difficult to see as Reinhardt's *Abstract Painting*. Based on a square module, it contains 144 lead plates, each measuring approximately one foot square and three-eighths of an inch thick. The sculpture is meant to be walked on, and Andre has asserted that a spectator who traverses such a work might not even see it: "You can stand in the middle of it and you can look straight out and you can't see that piece of sculpture at all because the limit of your peripheral downward vision is beyond the edge of the sculpture."[38]

Andre's *144 Lead Square* also shares with Reinhardt's *Abstract Painting* a simple title, descriptive of the work's most basic characteristics. Reinhardt usually titled his works on the verso, often placing the year of the painting's execution, and even its size, within quotation marks as part of the title; for example, *Abstract Painting, 60 x 60", 1964*.[39] This kind of titling underscores the artist's resistance to metaphorical interpretation — to finding in the work non-art concepts conjured up through the personal associations of the viewer. It was adopted by a number of the artists of the sixties and seventies, Andre and LeWitt among them — think not only of *144 Lead Square,* but also of *Straight Lines in Four Directions Superimposed,* and *Cubic-Modular Wall Structure, Black.*

Reinhardt's Writings

Artists of the 1960s were often as affected by Reinhardt's writing as by his painting. Throughout his career, he published cartoon satires of the art world, art-historical meditations, and polemical statements on art. He saw his

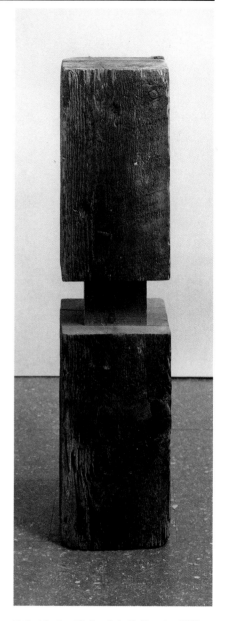

9. Carl Andre. *Timber Spindle Exercise.* 1964. Wood, 33 x 8 x 8" (84 x 20.3 x 20.3 cm). The Museum of Modern Art, New York. Gift of Mr. and Mrs. Michael Chapman

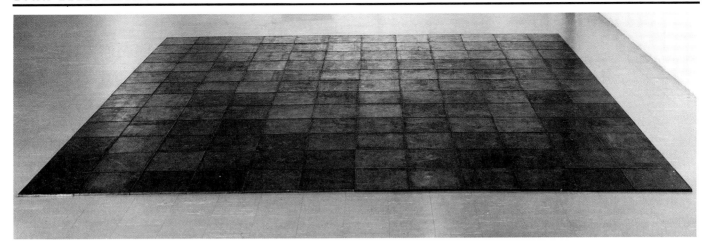

10. Carl Andre. *144 Lead Square.* 1969. 144 lead plates, each approximately ³/₈ x 12 x 12″ (.9 x 30.5 x 30.5 cm); overall, ³/₈ x 12′ 7/8″ x 12′ 1 1/2″ (.9 x 368 x 369.2 cm). The Museum of Modern Art, New York. Advisory Committee Fund

writing and painting as utterly distinct activities — painting belonged to the realm of art, writing and cartooning belonged to the realm of life, and he abhorred any mixing of the two.[40] But the following generation did not necessarily view Reinhardt's writing as a wholly separate occupation. For example, it seems likely that, through his statements, he unwittingly served as an inspiration for Conceptual art. This is quite paradoxical, as he certainly never advocated the notion of the supremacy of the idea — just the reverse.[41] Nevertheless, the manifestos of the movement's two most prominent advocates, LeWitt and Joseph Kosuth, have been strongly influenced by Reinhardt's writings.[42]

LeWitt acknowledges these statements' importance for him, saying that Reinhardt was the only one who took on critically, and with polemical force, what LeWitt considers the emotional excesses of Abstract Expressionism.[43] Lawrence Alloway has suggested that Reinhardt's writings may have provided a source for LeWitt's notion of Conceptual art, noting the strong similarities between Reinhardt's "Twelve Rules for a New Academy" and LeWitt's "Sentences on Conceptual Art."[44] At the very least, it seems likely that "Twelve Rules" provided the model for LeWitt's piece, which includes thirty-five brief statements that constitute guidelines for making contemporary art. Resemblances to Reinhardt's ideas and writing style are also evident in LeWitt's "Paragraphs on Conceptual Art." His comment, "New materials are one of the great afflictions of contemporary art. Some artists confuse new materials with new ideas. There is nothing worse than seeing art that wallows in gaudy baubles,"[45] closely parallels Reinhardt's, "No texture. Texture is naturalistic or mechanical and is a vulgar quality, especially pigment texture or impasto. Palette knifing, canvas-stabbing, paint scumbling and other action techniques are unintelligible and to be avoided."[46] Both artists adopt a moralizing tone that becomes comical when applied to painting techniques and sculptural materials. Each exaggerates for effect what he sees as the problem: "New materials are one of the great afflictions of contemporary art" and "action techniques are unintelligible and to be avoided." Like Reinhardt who,

with tongue-in-cheek snootiness, tells us that texture is a "vulgar quality," LeWitt characterizes new materials as "gaudy baubles." Reinhardt does not shrink from metaphor in his writing; with terms like "palette knifing" and "canvas-stabbing," he hilariously equates texture in painting with a violent crime.

Joseph Kosuth's treatises on Conceptual art also relate closely to Reinhardt's writings. In "Art after Philosophy, Parts 1, 2, and 3,"[47] Kosuth set forth his theory of art, in each installment acknowledging his debt to Reinhardt. (In Part 1 he states, "Reinhardt had a very clear idea about the nature of art, and his importance is far from recognized.")[48] Kosuth writes of subtitling all his works "Art as Idea as Idea," which mirrors Reinhardt's "Art-as-Art" in sound, though not in sentiment. Kosuth's tautological statement, "Art's only claim is for art. Art is the definition of art,"[49] is (in meaning as well as style) a simplified variation of Reinhardt's, "The one thing to say about art is that it is one thing. Art is art-as-art and everything else is everything else. Art-is-Art is nothing but art. Art is not what is not art."[50]

Reinhardt's importance for Conceptualism is ironic, given the artist's continued commitment to painting, his belief in artistic tradition as a carrier of meaning, and his disavowal of the "idea" as an essential component in art. LeWitt, who, unlike other Conceptualists, never dispenses with the art object, probably understands Reinhardt quite well and accepts their differences: "An artist may misperceive (understand it differently than the artist) a work of art but still be set off in his own chain of thought by that misconstrual."[51]

Kosuth provides a good example of this kind of "creative misunderstanding." He seems to almost willfully misinterpret Reinhardt, literalizing Reinhardt's claim that he was making the "ultimate painting," the last kind of painting that could be made, and using it as justification for the abandonment of the art object.[52] But he misunderstood Reinhardt no more than did Harold Rosenberg, who wrote, "The black monk of the anti–Abstract Expressionist crusade, Reinhardt represents to the most extreme degree the ideal of an art dominated by ideology. He calls for a type of painting utterly ruled by concept and executed according to recipe."[53] The idea that Reinhardt painted according to a recipe is belied by the fact that, within their common framework, the black squares vary greatly from work to work, the result of the artist's using different "blacks" in each canvas, his painting the cruciform shapes freehand, and the fact that he was able to reduce the element of chance in the paint's drying process only in the last year or so of his life.[54] Like Kosuth, Rosenberg does not seem to have recognized the discrepancies between Reinhardt's paintings and the artist's proclamations about them; and as a critic rather than an artist, his mistake is less easily justified.

If Kosuth misinterprets the intended relationship between Reinhardt's writing and his art, he is perceptive in his claim that the writings created a framework for the reception of the paintings:

. . . artists must take responsibility for the meaning of their work . . . it can't really be trusted to art critics and historians whose own careers make their relationship with art similarly creative. In the late sixties, the Greenberg regime might have succeeded in depicting Reinhardt as a minor color painter, but Reinhardt's own framing, which was as much a part of his activity as an artist as the painting of his paintings, stood in the way.[55]

By "Reinhardt's own framing," Kosuth means the older artist's writings and other public, extra-artistic activities.[56] And although Kosuth is correct to a point, by the late sixties, Greenberg notwithstanding, it seems the groundwork had been laid that would allow for an increasing appreciation of Reinhardt's contribution. Though there is no question that Reinhardt's writings affected (and continue to affect) the understanding of his art, no evidence exists to support Kosuth's implication that the artist intended them to play this role. Thus, Kosuth goes too far when he claims to have learned from Reinhardt's example that "artists make meaning and that is really where our activity is located, and all the things we do are part of our activity as an artist."[57] This is a lesson Reinhardt never meant to teach.

Misconstruing Reinhardt's motivations allows Kosuth to make his own art-critical point, which concerns the integration of art and life. Kosuth clearly believes the effect of Reinhardt's writings on the reception of his painting proves that an artist's life and art are necessarily intertwined — that all one's activities count. But even granting that his premise may be correct — that it may be impossible to achieve the kind of total separation of art and life Reinhardt sought — Kosuth's position distorts Reinhardt's intention. It reshapes it to resemble that of Marcel Duchamp, another of Kosuth's heroes, but an artist with whom Reinhardt felt no affinity at all.[58]

Robert Smithson also reinterprets concepts found in Reinhardt's painting and writing in a manner that diverges significantly from Reinhardt's intentions. In "Quasi-Infinities and the Waning of Space," Smithson actually misquotes Reinhardt from "Twelve Rules for a New Academy," to this effect: "The present is the future of the past and the past of the future." The sentence should actually read: "The present is the future of the past, *not* the past of the future." Reinhardt meant it to underscore the relationship to tradition.[59] Smithson goes on: "The dim surface sections within the confines of Reinhardt's standard (60" x 60") 'paintings' disclose faint squares of time. Time, as a colorless intersection, is absorbed almost imperceptibly into one's consciousness."[60] (Presumably Smithson placed quotation marks around the word "paintings" to indicate that, appearances to the contrary, the black squares should not be identified with this "obsolete" form; certainly Reinhardt would not have chosen to put them there.) Smithson is addressing the issue of duration, the time it takes to discern the subtle configuration of a

black Reinhardt. However, in Smithson's own art, the pervading notion of time is that of a fleeting moment, a present which is an instant caught between past and future. It is expressed in the ephemerality of such works as *Incidents of Mirror Travel in the Yucatán* (fig. 11), in which clusters of rectangular mirrors were configured at nine different sites on the Yucatán peninsula. Smithson wrote of the piece, "If you visit the sites (a doubtful probability), you will find nothing but memory traces, for the mirrors were dismantled right after they were photographed."[61] This emphasis on the ephemeral runs absolutely contrary to the importance Reinhardt placed on the physical art object and on artistic tradition.

11. Robert Smithson. *Incidents of Mirror Travel in the Yucatán* (one of nine configurations). 1968. No longer extant

Robert Morris, who studied the history of Oriental art under Reinhardt at Hunter College, also explores the notion of duration, the idea that it should take time for a viewer to fully perceive and comprehend an art work. If Morris gleaned this notion from Reinhardt's paintings, he uses it in a manner entirely different from the older artist's. His claim that "the experience of the work necessarily exists in time" rests on the idea that the new sculpture is defined, in part, by the "particular space and light and [changing] physical viewpoint of the spectator."[62] Morris's project is concerned with the circumstances in which the viewer encounters the work.[63] For him, the situation in which art is shown affects and even determines the nature and quality of an object's presence.[64] This kind of melding of art and environment is antithetical to the aims of Reinhardt's paintings, which are conceived without consideration for such variables, and are meant to remain as aloof as possible from them.

Reinhardt as Model

LeWitt has commented that Reinhardt was "the most cerebral of the painters of the fifties, and the one ideologically best-suited to the sixties,"[65] alluding to Reinhardt's role as a model of the artist-intellectual for that first generation of American artists mostly educated in universities, rather than in the studios of older artists. For certain members of the sixties generation, this aspect of Reinhardt's persona had an impact in addition to or apart from the formal and conceptual approaches offered in his painting and writing. Reinhardt's repetitive, polemical writing style, which mirrored the reduced aesthetic of his paintings, his outspokenness, his activist politics, his education at Columbia University and New York University's Institute of Fine Arts, and his career as a teacher of art history made him a figure especially consonant with the interests of this new breed of artist.

For Robert Morris, Reinhardt provided an example of how an artist might conduct his life. This involved pragmatic issues like the way artists earn a living and the part they might choose to play within the community, as well as intellectual concerns involving the nature of art. Morris attributes Reinhardt's interest in "negation,"[66] what he terms his "anti-humanism," to non-Western

influences: "He had seen enough 'primitive' and Neolithic art to understand that art was really about death and perhaps commemoration, and not about life."[67] Similarly, Richard Serra emphasizes Reinhardt's role as a model of "dispassionate articulation and sustained concentration"[68] who demonstrated how it was possible to have a voice without "becoming a movie star."[69]

It is significant that Reinhardt was the only member of his generation included in "A Museum of Language in the Vicinity of Art," Robert Smithson's far-ranging essay on, among other topics, artists' use of language.[70] Smithson begins the article with a quote from Reinhardt: "The Four Museums are the Four Mirrors," explaining that the article that follows is "a mirror structure built of macro and micro orders, reflections, critical laputas, and dangerous stairways of words, a shaky edifice of fictions that hangs over inverse syntactical arrangements." Smithson (like LeWitt, Morris, and Kosuth) then reinterprets Reinhardt's often-voiced advocacy of the "uselessness" of art: "Here language 'closes' rather than 'discloses' doors to utilitarian interpretations and explanations."[71] In the first part of the article, Smithson describes the writings of Dan Flavin, Andre, Morris, Judd, LeWitt, Reinhardt, Peter Hutchinson, Dan Graham, Andy Warhol, and Ed Ruscha. Following that, his musings involve the nature of the museum, history, and time, and a meditation on Reinhardt's satirical cartoon *A Portend of the Artist as a Yhung Mandala* (fig. 12). Smithson sees the center of the cartoon as the "void," bordered by an art world populated by monsters, "a tumultuous circle of teeming memories of the past."[72]

Ad Reinhardt's importance for the artists of the sixties took many forms. If it is sometimes difficult to define, this is because his is an art cloaked in a series of paradoxes: his painting represents a closure, the end of something, and yet, for him, art drew its meaning from its connection with an ongoing tradition; his paintings are material objects, yet they seem to deny their physicality; he insisted on the complete separation of his art work from his writing (as he did of art from life), yet during the sixties and after, the writings evidently informed the reception of his painting; and, perhaps most paradoxical of all, the work of the artists most influenced by him generally bears little overt resemblance to his.

Despite such apparent contradictions, it is his delicate, seemingly ephemeral and almost immaterial black squares that carried the point. Aggressive in their very reticence, their resistance to yielding up their secrets, they imposed themselves forcefully and with great insistence. These paintings remain difficult to perceive optically, and difficult to comprehend intellectually; they must be viewed on their own terms, and over an extended period of time. In New York at the beginning of the sixties, there was a small audience of younger artists ready and willing to do just that.

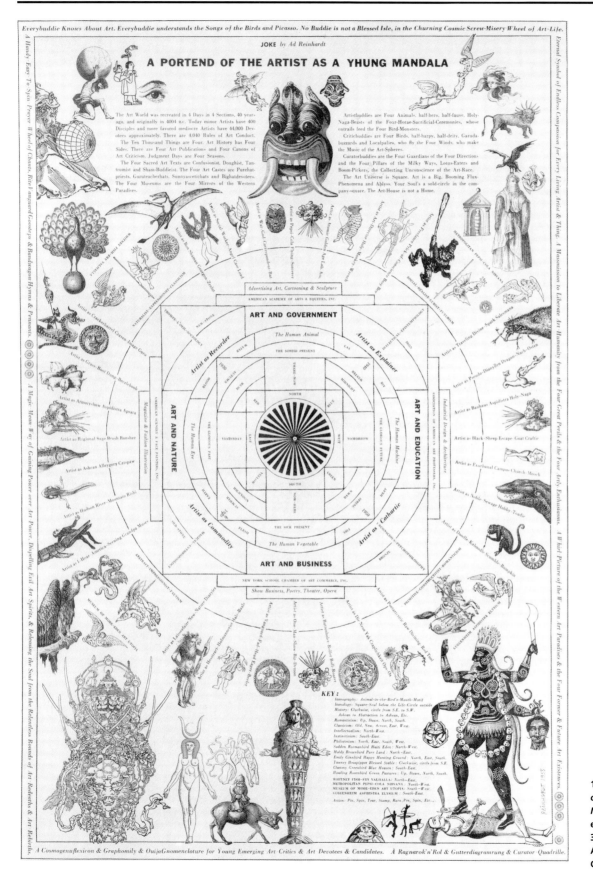

12. Ad Reinhardt. *A Portend of the Artist as a Yhung Mandala*. 1956. Cut and pasted paper, 20 1/4 x 13 1/2" (51.4 x 34.5 cm). Whitney Museum of American Art, New York. Gift of an anonymous donor

Notes

1. Irving Sandler claims that, in the 1950s, Reinhardt's "geometric abstractions were widely put down as a throwback to the thirties," and that The Museum of Modern Art reflected this attitude when it excluded him from the 1958 exhibition "New American Painting" (Sandler, "Reinhardt: The Purist Backlash," *Artforum*, 5 [December 1966], p. 46). If this was the case, there is little evidence of it in print. Although Reinhardt was not an "art star," even by early-sixties standards, he was an established figure and his shows were reviewed regularly. Most reviewers gave his paintings respectful consideration. One notable exception was Fairfield Porter, whose often-quoted statement that Reinhardt's "drug-store bright colors of almost the same value . . . make your eyes rock" was not meant as a compliment. Porter went on: "He is not the first artist to do this, nor does he do it with enough precision to make it clear whether it is intended." Porter also complained of what he termed the paintings' "lack of scale" (Porter, "Ad Reinhardt," *Art News*, 50 [February 1952], p. 41).

2. "In my opinion, Reinhardt is the intellectual pivot of the new art offered as a replacement for Abstract Expressionism" (Harold Rosenberg, "Black and Pistachio" [1963], in *The Anxious Object* [Chicago: University of Chicago Press, 1964], p. 52).

3. In 1965 Lucy Lippard wrote, "Reinhardt is now recognized as a rebel and a prophet and is widely admired, but he was a precedent for, rather than an influence on, recent trends" ("New York Letter," *Art International*, 9 [May 1965], p. 52).

 In 1966, Kynaston McShine concurred: "It has been suggested that Reinhardt is the forerunner and major influence on the younger group of artists who have been described as 'rejective,' 'minimal,' 'systemic,' 'structural,' and even 'boring.' I would prefer to think that his work along with that of a few others provided the viable climate. It is inconceivable that Reinhardt, who has always asserted the autonomy of both art and the artist, should at this point assume the role of sole dean to what one hopes will not become a New Academy" ("More than Black: The Positive of Negative Art," *Arts Magazine*, 41 [December 1966–January 1967], p. 50).

4. See Robert Morris, "Notes on Sculpture," in Gregory Battcock, ed., *Minimal Art: A Critical Anthology* (New York: E. P. Dutton, 1968), p. 223: "Sculpture . . . never having been involved with illusionism could not possibly have based the efforts of fifty years upon the rather pious, if somewhat contradictory, act of giving up this illusionism and approaching the object . . . the sculptural facts of space, light, and materials have always functioned concretely and literally." See also Donald Judd, "Specific Objects," in *Donald Judd: Complete Writings, 1959–1975* (Halifax: Press of the Nova Scotia College of Art and Design; New York: New York University Press, 1975), p. 189: "George Brecht and Robert Morris use real objects and depend on the viewer's knowledge of these objects."

5. For more on Smithson's interest in crystals, see Robert Hobbs, *Robert Smithson: Sculpture* (Ithaca and London: Cornell University Press, 1981), p. 12.

6. "In part my work was congruent with the sculptors', especially in their focus on objecthood, then a primary and timely concern. . . . But paintings, while objects, are not sculptures. . . . There can be no mark within a painting's format which does not deceive. . . . I painted my straight edges curved to make them look straight (entasis) preferring an open dialogue of illusion/physicality to simplistic, one-dimensional fiat" (Jo Baer, quoted in *Abstraction, Geometry, Painting: Selected Geometric Painting in America Since 1945* [New York: Harry N. Abrams, 1989], p. 178).

7. Robert Mangold, quoted in *Abstraction, Geometry, Painting*, p. 172.

8. In his writings, Reinhardt often plays with the idea of the "ultimate," but typically leaves his meaning ambiguous. In an unpublished statement, Reinhardt writes, "I made the ultimate painting first, that's all . . . What's more, this is the end of the beginning, that's all" ("What's More, That's All," undated, unpublished notes, Archives of American Art, N69-103). In another statement, he questions, "End of Painting as Art? Working in form nearing end of its time? Shot its bolt from the blue." But he ends the piece with, "Last word must always be secretly the first" ("End," in *Art-as-Art: The Selected Writings of Ad Reinhardt*, ed. Barbara Rose [New York: Viking Press, 1975], pp. 113–14).

9. Virginia Dwan, taped interview with the author, November 9, 1990. The characterization of Reinhardt as an "underground" figure, accurate as it may be, is more than a little ironic, considering his many years as a highly vocal and visible member of the art community.

10. Reinhardt believed that his black paintings had a marked ability to antagonize the public. The artist told Bruce Glaser: "When The Museum of Modern Art had its last fifteen or sixteen Americans show in nineteen sixty-three they had to rope off my room, and the public got angry only with that room. They accepted everything else in the show — the pop art, the plaster hamburgers and everything else"

(Glaser, "An Interview with Ad Reinhardt [1966–67]," in *Art-as-Art,* p. 15). In "The Black Square Painting Shows, 1963, 1964, 1965," Reinhardt writes of how barriers had to be erected for exhibitions of his work in various international locations (*Art-as-Art,* p. 85). There is certainly truth in Reinhardt's claim for the works' ability to arouse hostility, but it is also the case that the black paintings are extremely fragile, and even the slightest contact with people or things, that would not injure other canvases, can do lasting damage to a late Reinhardt.

11. The exhibition was held October 4–29, 1966, and included Carl Andre, Jo Baer, Dan Flavin, Donald Judd, Sol LeWitt, Agnes Martin, Robert Morris, Reinhardt, Robert Smithson, and Michael Steiner. A meeting of the artists sparked heated debate; it was impossible for them to agree on a catalogue text. Dwan had wanted an essay that would illuminate their commonalities. Smithson had proposed a text "full of galactic, frozen imagery, but it was met with icy silence. And so the catalogue remained mute, with no more description than [the brief title]" (Dwan, interview with the author). Reinhardt, who had admired Martin's work for some time, had recommended her to Dwan. It was during the organization of this exhibition that he had his only personal contact with Andre and LeWitt.

12. Sol LeWitt, interview with the author, November 9, 1990.

13. Ibid.

14. LeWitt most effectively "democratizes" art in his books. Lucy Lippard notes that, far from being "minor" works, these are among his most developed, "their implicit portability, inexpensiveness, and seriality being among their strongest points"; they "offer more art for less" (Lippard, "The Structures, The Structures and the Wall Drawings, The Structures and the Wall Drawings and the Books," in Alicia Legg, ed., *Sol LeWitt* [New York: The Museum of Modern Art, 1978], pp. 27–28).

15. Reinhardt usually framed his canvases before he began working on them. He laid the canvases flat to paint them and stood them up when he needed to examine his efforts. Until the last year of his life, he worked alone, without the aid of assistants, and the frames offered protection for the paintings as he lifted them and moved them around the studio (Rita Reinhardt, conversation with the author, March 4, 1991).

16. "The one object of fifty years of abstract art is to present art-as-art and as nothing else, to make it the one thing it is only, separating and defining it more and more, making it purer and emptier, more absolute and more exclusive. . ." (Ad Reinhardt, "Art-as-Art," in *Art-as-Art,* p. 53).

17. Rosalind Krauss, "Grids" (1978), in *The Originality of the Avant-Garde and Other Modernist Myths* (Cambridge, Mass., and London: MIT Press, 1985), pp. 12–13.

18. "The idea itself, even if not made visible, is as much a work of art as any finished product" (Sol LeWitt, "Paragraphs on Conceptual Art," *Artforum,* 5 [Summer 1967], p. 83).

19. For an explication of the obsessive nature of LeWitt's work, see Rosalind Krauss, "LeWitt in Progress" (1978), in *The Originality of the Avant-Garde and Other Modernist Myths,* pp. 251–53.

20. Frank Stella describes "relational" and "nonrelational" art as follows: ". . . European geometric painters really strive for what I call relational painting. The basis of their whole idea is balance. You do something in one corner and you balance it with something in the other corner. Now the new painting is being characterized as symmetrical . . . but we use symmetry in a different way. It's nonrelational. . . . The balance factor isn't important" (Bruce Glaser, "Questions to Stella and Judd," in Battcock, ed., *Minimal Art,* p. 149).

21. Ad Reinhardt, "Twelve Rules for a New Academy," in *Art-as-Art,* p. 205.

22. Sol LeWitt, "Sentences on Conceptual Art," *Art-Language,* 1 (May 1969), p. 12.

23. See Bernice Rose, "Sol LeWitt and Drawing," in Legg, ed., *Sol LeWitt,* p. 31.

24. For example, Donald Kuspit writes, "The key to these paradoxes [in LeWitt's art] . . . is the absolute intention that brought LeWitt's objects into being but that cannot rest comfortably with them once they exist. The paradoxes express this conflict, inherent to an intention that is always outreaching its physical embodiments, for they never quite bespeak its true purpose, viz., the intuition of an ideal art" (Kuspit, "Sol LeWitt: The Look of Thought," *Art in America,* 63 [September–October 1975], p. 46).

25. Sol LeWitt, interview with the author, December 17, 1990. Reinhardt used the term "absolute" in relation to his own work. He characterized his ideas as "an absolute aesthetic point of view," stating that he believed that in art there were certain pure and absolute standards, and equating this notion with "purism," in the sense of both a lack of corruption and a classical style of painting (see Glaser, "An

Interview with Ad Reinhardt," pp. 18–20).

26. See David J. Clarke, *The Influence of Oriental Thought on Postwar American Painting and Sculpture* (New York and London: Garland Publishing, 1988), p. 147.

 Lucy Lippard refers to Reinhardt's "desire for a quasi-Oriental absolute" (Lippard, "The Structures, The Structures and the Wall Drawings, The Structures and the Wall Drawings and the Books," p. 26).

27. Ad Reinhardt, "[The Black Square Paintings]," in *Art-as-Art*, pp. 82–83.

28. Reinhardt's cruciform shapes are Greek crosses in that their horizontal and vertical bars intersect at the midpoint of each and are of equal length and width. However, the horizontal and vertical bars of the crosses in Reinhardt's paintings are not wholly equal: they are almost always of different hues, and one is often more prominent than the other.

29. Reinhardt mixed paint from tubes in jars, adding turpentine to facilitate the process of separating the pigment from its medium, which was oil. The procedure required constant stirring to ensure evenness in the distribution of pigment as well as oil. Over time, the turpentine would evaporate, and the oil would separate from the pigment and could be poured off. The resulting mixture was dense rather than transparent, because it contained a high proportion of pigment, but it was thin enough to do away with the ridges that normally result from the brushing on of oil paint. Reinhardt applied many layers of these mixtures to create his black paintings (Rita Reinhardt, conversation with the author, February 4, 1991).

30. See Glaser, "An Interview with Ad Reinhardt," p. 22.

31. Ibid., pp. 22–23.

32. Ibid. Glaser notes that "resistant" was a word with currency among younger artists at the time, who talked of "the resistant canvas or difficult paintings." Reinhardt approved of the idea of testing the audience.

33. Sol LeWitt, interview with the author, December 17, 1990.

34. "Reticence" is another term that has been used often in relation to Minimal art. See, for example, Andrea Miller-Keller, "Excerpts from a Correspondence, 1981–1983" in *Sol LeWitt: Wall Drawings, 1968–1984* (Amsterdam: Stedelijk Museum, 1984), p. 19.

35. Carl Andre, letter to the author, December 1, 1990.

36. Quoted in Jeanne Siegel, "Carl Andre: Artworker," *Studio International*, 180 (November 1970), p. 179.

37. Carl Andre, "Quotations from the Artist," in *Carl Andre* (The Hague: Haags Gemeentemuseum, 1969), p. 5.

38. Quoted in David Bourdon, *Carl Andre: Sculpture, 1959–1977* (New York: Jaap Rietman, 1978), p. 31.

39. Reinhardt's practice of titling and dating his works on the verso presents certain problems in establishing a chronology for pictures. He generally inscribed them just before they left his studio, usually for an exhibition. Often paintings must have been dated months or even years after work on them was completed. When unsold pictures returned to his studio, he frequently repainted the canvases in the manner in which he was then working. It is possible that the versos of some canvases bear the dates of earlier paintings. In the case of the fragile black pictures, Reinhardt often had to restore them long after they had left his studio; his method was generally simply to repaint them. A number of these works have dates that indicate that they were worked on in two campaigns, but it is likely that others that were also repainted have dates that do not reflect that fact. See *Ad Reinhardt* (Los Angeles: The Museum of Contemporary Art; New York: The Museum of Modern Art and Rizzoli International Publications, 1991), p. 101.

40. This is the fundamental message of Reinhardt's "Art-as-Art Dogmas." For example: "The one nature of art fixes a boundary that separates it from every other nature and thing. . . . The one reality of art is just the reality of art, not the reality of reality, just the life of art not the life of life . . ." (Reinhardt, "Art-as-Art," p. 57).

41. "No good ideas in art" (Ad Reinhardt, ["Art-as-Art"], in *Art-as-Art*, p. 75).

42. See LeWitt, "Paragraphs on Conceptual Art" and "Sentences on Conceptual Art"; and Joseph Kosuth, "Art after Philosophy [Part 1]," *Studio International*, 178 (October 1969), pp. 134–37; "Art after Philosophy, Part 2," *Studio International*, 178 (November 1969), pp. 160–61; "Art after Philosophy, Part

3," *Studio International,* 178 (December 1969), pp. 212–13.

43. LeWitt, conversation with the author, November 9, 1990.

44. Lawrence Alloway, "Sol LeWitt: Modules, Walls, Books," *Artforum,* 13 (April 1975), p. 40.

45. LeWitt, "Paragraphs on Conceptual Art," p. 83.

46. Reinhardt, "Twelve Rules for a New Academy," p. 205.

47. See note 42, above.

48. Kosuth, "Art after Philosophy," p. 136.

49. Ibid., p. 137.

50. Reinhardt, "Art-as-Art," p. 53. Kosuth actually quotes this Reinhardt passage in "Art after Philosophy," p. 134.

51. LeWitt, "Sentences on Conceptual Art," p. 12.

52. "[Reinhardt's] painting of 'the last paintings anyone can make,' like the circularity of his writing, began . . . that self-reflexive spiral which was also painting's self-erasure in its very act of completion" (Joseph Kosuth, statement at a panel discussion held at the Solomon R. Guggenheim Museum, New York, in conjunction with the exhibition "Ad Reinhardt and Color," 1980; audiotape on deposit at the Guggenheim).

53. Rosenberg, "Black and Pistachio," p. 53.

54. Reinhardt's process of leaching the oil out of his paint caused certain difficulties. If the remaining oil was not evenly distributed throughout the paint mixture, streaks that could only be detected after the canvas was dry would appear on the surface. A great deal of stirring of the paint and turpentine mixture was required to avoid this problem (Rita Reinhardt, conversation with the author, February 4, 1991).

55. Kosuth, Guggenheim Museum panel discussion.

56. "Ad Reinhardt made black paintings, yes. But he also wrote texts, made cartoons, did diagrams, taught art, participated in panel discussions, gave public lectures, and so on. He did *all* of these things as an artist and thereby created a meaning context which affected our understanding — and perception — of those black paintings" (Joseph Kosuth, letter to the author, May 20, 1991).

57. Joseph Kosuth, taped interview with the author, October 1, 1990.

58. In a lecture at the Skowhegan School in the summer of 1967, Reinhardt stated that he "never liked or approved of anything about Duchamp," and that he had always felt one had to make a choice between Duchamp and Mondrian; there is no question as to where his allegiances lay (audiotape on deposit with the Skowhegan School of Painting and Sculpture, Skowhegan, Maine).

59. Reinhardt, "Twelve Rules for a New Academy," p. 206.

60. See Robert Smithson, "Quasi-Infinities and the Waning of Space," *Arts Magazine,* 41 (November 1966), pp. 28–31.

61. *The Writings of Robert Smithson,* ed. Nancy Holt (New York: New York University Press, 1979), p. 103.

62. Robert Morris, "Notes on Sculpture, Part 2," in Battcock, ed., *Minimal Art,* p. 234.

63. See Michael Fried, "Art and Objecthood," in Battcock, ed., *Minimal Art,* p. 125.

64. Ibid., p. 127. Fried states that, for Morris, "Everything counts — not as part of the object, but as part of the situation in which objecthood is established and on which it depends."

65. LeWitt, interview with the author, December 17, 1990.

66. In his black paintings, Reinhardt was always "painting out," "destroying"; he termed these works "negative presences" (Glaser, "An Interview with Ad Reinhardt," p. 17). In the same interview Reinhardt explained, "The painting, which is a negative thing, is the statement, and the words I've used about it have all been negative to keep it free" (p. 14).

67. Robert Morris, taped interview with the author, November 9, 1990.

68. Richard Serra, interview with the author, January 23, 1991.

69. Richard Serra, Guggenheim Museum panel discussion.

70. Robert Smithson, "A Museum of Language in the Vicinity of Art," *Art International,* 12 (March 20, 1968), pp. 21–27.

71. Ibid., p. 21.

72. Ibid., p. 24.

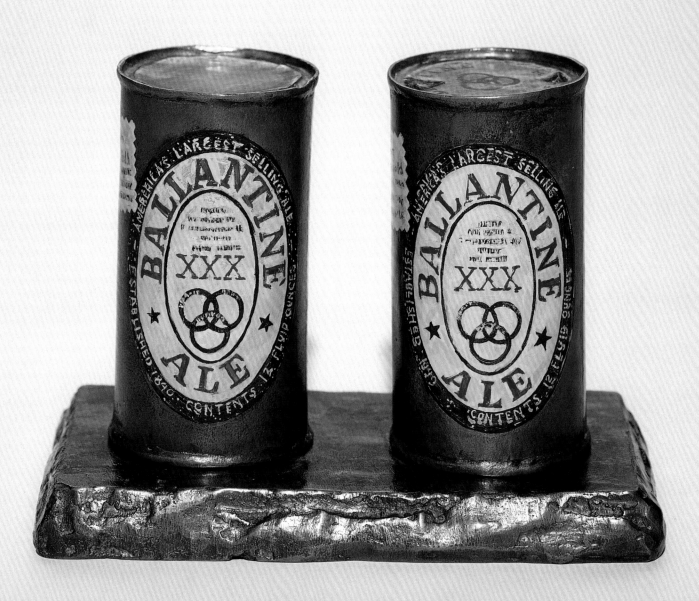

Bronze. The first graphic work based on the sculpture is the celebrated 1964 lithograph *Ale Cans* (fig. 4), printed at Universal Limited Art Editions in West Islip, Long Island. Johns began working on this print while completing the second cast of the sculpture,[18] and it is his first print to depict one of his sculptures.[19] Casting and painting the second *Painted Bronze* may have provided the inspiration to try the image on paper. (Similarly, Johns had made his first prints in 1960, the same year he executed his bronze sculptures.)[20] The materiality of printmaking — the transference from stone to paper, the reversal of the image — is not unlike the process of molding, casting, and painting bronze. In both mediums, the artist builds up his image in one material, and the final art work is made of another. There is also a collabora-

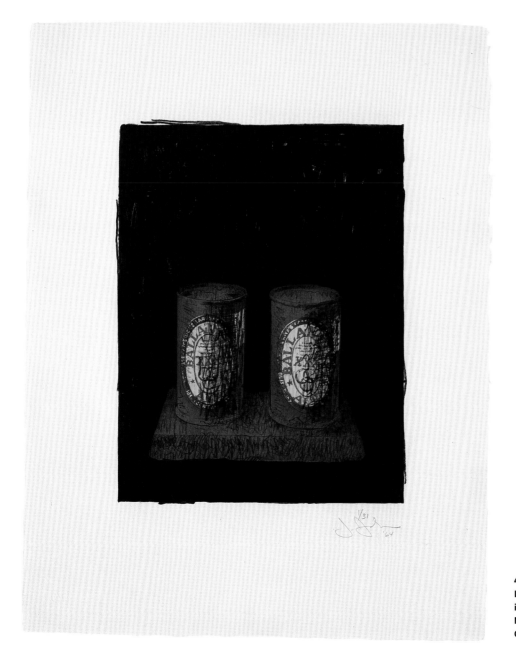

4. Jasper Johns. *Ale Cans*. West Islip, Universal Limited Art Editions, 1964. Lithograph, printed in color, 22 7/8 x 17 3/4" (58.1 x 45.1 cm). The Museum of Modern Art, New York. Gift of the Celeste and Armand Bartos Foundation

tive nature to both mediums, the artist's talents combining with the skills of the printer or foundry worker. His facility as a lithographer notwithstanding, the working similarities of both mediums may suggest why Johns chose lithography when making this first two-dimensional version of his famous sculpture.

Although this print is often considered Johns's most illusionistic to date, it is not the first print in which he uses illusionistic devices, as Riva Castleman has pointed out.[21] In his first color lithograph, *Painting with Two Balls* of 1962 (ULAE 8), two small round balls appear to intrude between the upper and middle horizontal bands.[22] But while that print is an overall composition of flat texture interrupted by subtle objects, *Ale Cans* is just the opposite: its objects dominate, challenging Johns to avoid a mere realistic representation.

The importance of the sculpture's base is particularly relevant here. Johns alternatively made sculptures with or without a base, as in *Light Bulb I* and *Light Bulb II* of 1958. This distinction makes a striking difference in the perception of these works. Posed on a base, the ale cans read more clearly as art object, a work of sculpture resting on its bronze support. Johns's thumbprint, the autographic mark that certifies the piece as hand-made, is imprinted on the base. The base also serves to unite the two cans into one sculpture and reinforce their reading as a still life, creating a context for the individual ale cans. When compared to the other sculpture titled *Painted Bronze* — the Savarin can, which has no base — the ale-can bronze is perceived as art object, while the paintbrush can seems almost a Duchampian Readymade, devoid of aesthetic context.

In *Ale Cans,* Johns depicts the base in perspective, foreshortened as it recedes into the background. This is the first case where he has used this kind of perspective in his printmaking. The cans appear to be positioned in a black setting, whose dimensions have been determined by the olive base. Johns has created an environment in which to view his sculpture, a context that will be emphasized in later prints.

Ale Cans stands on its own as a compelling and convincing work of art. But knowledge of *Painted Bronze* alerts the viewer to the subtle layers of perceptual investigation in the lithograph. As Richard Field has written, the print of a recognizable Johnsian image "serves to underscore that which remains constant: the process of seeing itself."[23] The visual game is no longer one of object-replication. Ale-can prints could not become objects the same way that Flag paintings did. The printed image clearly sits on a piece of paper, its white margins reinforcing its "paperness" and two-dimensionality. Johns exploited this opportunity, inherent in printmaking, by playing the illusionistic image of the sculpture against the flatness of the paper, to enhance his perceptual puzzle.

Working Proofs for *Ale Cans*, 1964

Johns donated five working proofs for *Ale Cans* to The Museum of Modern Art in memory of Tatyana Grosman, the founder of Universal Limited Art Editions, in 1985, at the time of the dedication of the Museum's Tatyana Grosman Gallery. Tatyana Grosman had been the driving force behind Johns's printmaking career, persuading him to make his first print, in 1960. The proofs he donated, which reveal the creative process behind one of his landmark printed images, seem a fitting tribute. This is in keeping with the way that Johns's repetitions of imagery often evoke a sense of remembrance, a reference back to a progenitor. *Ale Cans,* made as a memorial to a sculpture, becomes a memorial to a friend.

The working proofs leading up to the print are invaluable to understanding Johns's process of translating a sculpture into a lithograph. When making a lithograph, each color is drawn on a separate stone. Proofs can be pulled at any stage in the print's development, allowing the artist to return to the stone and modify what he has drawn; these preliminary stages are known as trial proofs. Johns often draws by hand on trial proofs to experiment with and resolve the next stage of the print, and it is these overdrawn proofs that he refers to as working proofs. He has often made extended series of working proofs for prints.[24] Their drawn revisions allow him to reevaluate an image without reworking the plate or stone. Since there are no preliminary drawings for the print, the set of working proofs for *Ale Cans* provides the only clues to the progressive development of the graphic image. He is also very interested in the different surfaces attainable with different mediums, as well as the contrast between printed and hand-applied textures, and has explored numerous such variations within this series of *Ale Cans* proofs.[25] Each working proof stands on its own as a finished and unique work of art, and Johns has allowed them to be shown as such. But when considered as a series of investigations of a particular image, they offer insight into the working habits of an artist to whom process is often the most important motivation.

Johns annotates each proof with exactness, indicating which are trial proofs, which are working proofs, and what mediums are added by hand. Although a precise order of the proofs is difficult to determine, progressions of details help to establish their sequence.

The first working proof (fig. 5), printed on newsprint, reveals that the black background was an early decision. The background is the only printed element in this proof; the areas for the cans and base are left blank, with crayon additions loosely defining their form. Johns has said that the dark background was important as a means to flatten out the spatial depth.[26] It is interesting to note that a typical Johnsian scribble, which becomes very important as a further element reinforcing the idea of two-dimensionality, is already evident in the crayon drawing over the outline of the left can.

Duchamp's *Chocolate Grinder* of 1913 could serve as a source for an

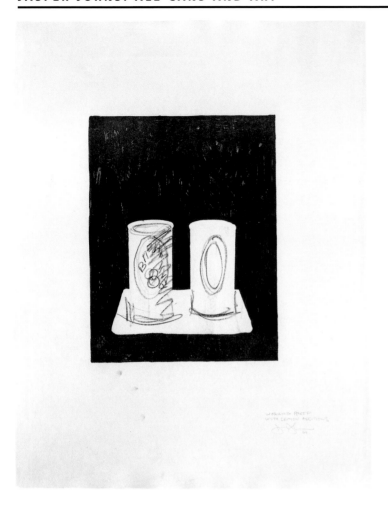

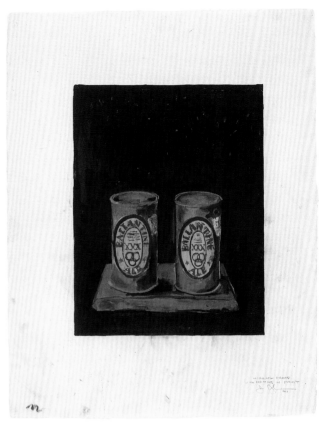

image starkly portrayed against a somber, dark background.[27] It is a strictly illusionistic image of a manufactured metal object, sitting on a base, with its title printed in gold lettering. It has also been suggested that the source for the background may have been the cover of Leo Steinberg's 1963 monograph on Johns, which illustrates *Painted Bronze* against shiny black.[28] Whatever the inspiration, the effect of the black is not only spatial ambiguity but an intensified sense of the melancholic spirit evident in the sculpture.

The second working proof (fig. 6), hand-painted with gouache and acrylic paints mixed with metallic powders, is the most illusionistic of the proofs. It is the black background alone that flattens the space of this beautiful perspective rendering of *Painted Bronze*. As in the first proof, only the background is printed, indicating an early stage in the progression of proofs. There is a certain density to the image because of the texture of the painting, with large areas of the lithographed background covered with gray and black gouache. This stylistic heaviness adds to the emotional heaviness of the piece, while simultaneously conveying a sense of the bronze material of the sculpture through the use of shimmering, reflective gold paint. The labels are delicately painted in green, red, and ocher, creating the initial sense of realism.

Left:
5. Jasper Johns. *Ale Cans,* working proof. 1964. Lithograph with crayon additions, 26 9/16 x 20 5/8″ (67.5 x 52.4 cm). The Museum of Modern Art, New York. Gift of the artist in honor of Tatyana Grosman

Right:
6. Jasper Johns. *Ale Cans,* working proof. 1964. Lithograph with paint additions, 22 9/16 x 17 5/8″ (57.4 x 44.8 cm). The Museum of Modern Art, New York. Gift of the artist in honor of Tatyana Grosman

More important, however, Johns has painted shadows on the right sides of the cans and the base, conveying depth as though the image were lit from the left. The puncture holes are clearly visible on the top of the left can, adding a further illusionistic detail to this most realistic depiction of the sculpture. There is also a fingerprint in the gray gouache on the lower right of the base, very close to where Johns imprinted his thumb on the sculpture to indicate its hand-made status. All of these elements contribute to making this proof the most specific tribute to *Painted Bronze.*

With the next two working proofs, Johns abandons the realistic depiction of the sculpture in favor of more abstract renderings. The black background and olive cans and base are now printed, with a metallic ink used for the cans to simulate the bronze of the sculpture. The shadows added to the second proof, however, are not re-created here. The labels in both pieces are merely sketched in, with no words discernible.

On the third proof (fig. 7), the ocher label has been applied with crayon, as has the red and black scribbling. These black crayon lines suggest the rounded volume of the cans. As first mentioned by Castleman, such markings are evident in the earlier lithograph *Painting with Two Balls.* These energetic black lines, printed along the left half of the image, however, act as pictorial rather than spatial devices.[29] In the fourth proof (fig. 8), the label back-

Left:
7. Jasper Johns. *Ale Cans,* working proof. 1964. Lithograph, printed in color with chalk and crayon additions, 22 13/16 x 17 3/4" (58 x 45.1 cm). The Museum of Modern Art, New York. Gift of the artist in honor of Tatyana Grosman

Right:
8. Jasper Johns. *Ale Cans,* working proof. 1964. Lithograph, printed in color with ink and crayon additions, 22 5/8 x 17 5/8" (57.5 x 44.8 cm). The Museum of Modern Art, New York. Gift of the artist in honor of Tatyana Grosman

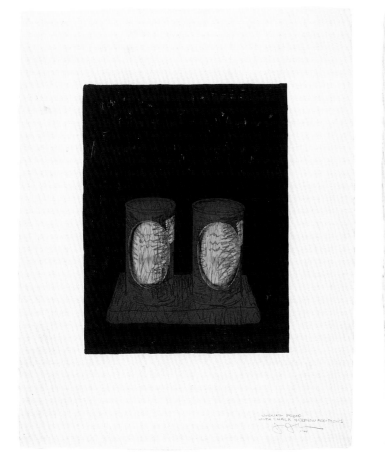

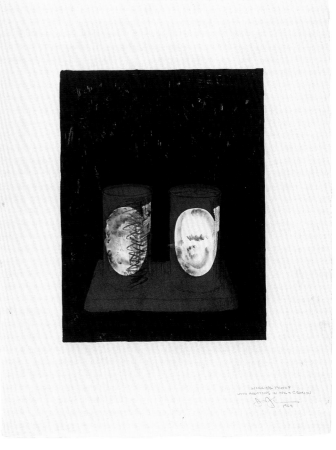

grounds are left blank, allowing the white of the paper to show through. The cans are thereby dramatically flattened out against the picture plane. The black crayon lines are on the left can only, with its heavily colored label, contrasting with the starker, flatter, mirror-like look of the label on the right. In the third proof there is an overall pattern of black lines on the cans and base which enhances a feeling of depth; in the fourth, however, Johns has omitted these lines, which further pushes the image up against the picture plane. The color markings in the labels of the fourth proof are predominantly made out of the artist's fingerprints, which generate an exceptionally beautiful texture and contrast with the printed surfaces of the background and the cans.

In the making of a print, an artist often finds himself waiting for extended periods of time while the printers are proofing, adjusting, or making corrections. Johns frequently used this time in the printshop for further experimentation with his images. During such a period, while working on *Ale Cans,* he transformed one of the numerous proofs with collage elements and hand-drawn additions in ink and crayon (fig. 9). Always meticulous about the titles, mediums, and dating of his work, Johns originally annotated this piece "Working proof with collage, ink and crayon additions."[30] But in the early eighties, he erased that notation, deciding that the work had not been conceived in the development of the final print, but as a distinct, individual project.

The collage elements are two roughly cut pieces of tracing paper, one placed over each can's label. Found in the workshop, the tracing paper was the stencil being used for the lettering BALLANTINE ALE that appears in red on the final print. The black and olive colors in the background, cans, and base are already printed, but Johns has added white, gray, and black crayon over and under the collage. The complexity of the composition is again evidenced by the fact that Johns decided to print the stone with the black outline partly in white, most noticeable in the white lines that run off the right side of the right can. He explores the visual effects of overlaying printed and hand-drawn textures in this piece more than in any of the other proofs. There are various fingerprints on the base and right can; the black outlining rectangle has been drawn in crayon.

The overall effect of this captivating, essentially monochromatic collage is one of hidden mystery. The density caused by the numerous layers — drawing over collage over drawing over print — by seeing through one layer to the masked one beneath, makes this the most distinctive interpretation of the printed image. It reaches a level of abstraction from the sculpture exceeding that of the third and fourth working proofs. Here, two-dimensionality is established not merely by the density of the dark background and the outlining black rectangle, but through the flattening effect of the collaged paper. By partially obliterating the labels yet leaving traces in gray, and tempting the viewer to read beneath the surface, Johns has created an afterimage on paper, a ghost-like souvenir of his *Painted Bronze.*

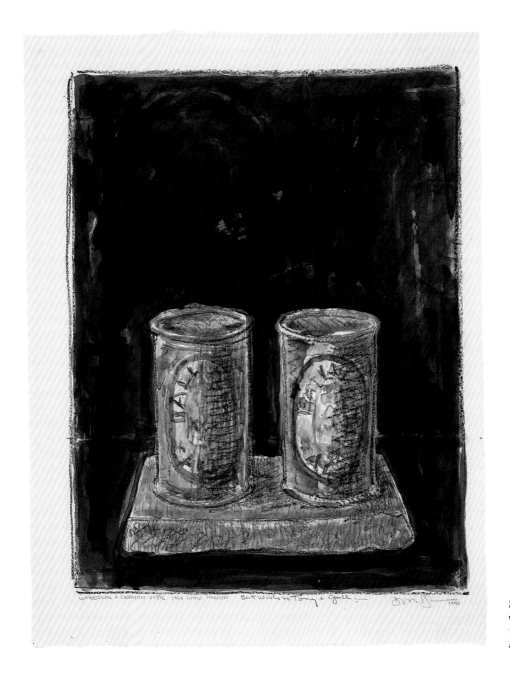

21. Jasper Johns. *Ale Cans*. 1990. Lithograph with watercolor and crayon additions, 16 1/2 x 12 7/8" (41.9 x 32.7 cm). Private collection, Los Angeles

Notes

In the captions, the dimensions indicated for works on paper refer to sheet size, with height preceding width. A date given in parentheses is not inscribed on the work.

All paintings and sculptures by Jasper Johns mentioned in the text are illustrated in Michael Crichton, *Jasper Johns* (New York: Harry N. Abrams in association with the Whitney Museum of American Art, 1977). Prints mentioned in the present text but not illustrated are identified by a ULAE number, referring to *The Prints of Jasper Johns, 1960–90: A Catalogue Raisonné,* forthcoming from Universal Limited Art Editions, West Islip, New York.

1. Jasper Johns, "Sketchbook Notes" (1965), *Art and Literature,* 4 (Spring 1965), pp. 185–92.

2. Jasper Johns, interview with the author, November 6, 1990.

3. Both versions of *Glass of Absinth* are illustrated in William Rubin, *Picasso and Braque: Pioneering Cubism* (New York: The Museum of Modern Art, 1989), p. 323.

4. The bronze sculptures were cast at Modern Art Foundry, 18-70 41st Street, Long Island City. They are *Light Bulb,* four casts; *Flashlight; Painted Bronze* (ale cans), two casts; *Painted Bronze* (paintbrushes); *Flag,* four casts; and *Bronze (Light Bulb, Socket, Wire on Grid),* four casts.

From the outset, Johns intended to make two casts of *Painted Bronze* (ale cans). The second cast, however, was not completed until 1964. It differs slightly from the first in its painting but otherwise appears the same. A topic of frequent confusion, the correct identification of the second cast is: *Painted Bronze,* 1960 (2/2, cast and painted in 1964).

5. "Jasper Johns: Drawings and Sculpture," Leo Castelli Gallery, New York, January 31–February 25, 1961.

6. Johns's first doubled work appeared the previous year, 1959, with the painting *Two Flags.*

7. Illustrated in *Robert Rauschenberg* (Washington, D.C.: National Collection of Fine Arts, 1976), p. 93.

8. On the relationship with Duchamp, see Max Kozloff, "Johns and Duchamp," *Art International,* 8 (March 1964), p. 42.

9. Quoted by Johns in his review of Duchamp's *The Green Box,* in *Scrap,* no. 1 (December 23, 1960), p. 4.

10. Jasper Johns, "Thoughts on Duchamp," *Art in America,* 57 (July–August 1969), p. 31. For an analysis of Duchamp's influence on Johns's sculpture, see Roni Feinstein, "New Thoughts for Jasper Johns' Sculpture," *Arts Magazine,* 54 (April 1980), pp. 139–45.

11. The idea of viewer participation appears as early as 1955, in *Target with Plaster Casts,* in which the lid over each cast is movable, and continues in works such as *Tango,* with its inviting crank. Johns conveys this idea most clearly in *Jasper Johns and . . .* (1971), an editioned object including a simply drawn black-target lithograph with a paintbrush and three watercolor pads collaged below it, ostensibly proposing that the viewer/owner complete the piece.

12. Anne d'Harnoncourt and Kynaston McShine, eds., *Marcel Duchamp* (New York: The Museum of Modern Art; Philadelphia: Philadelphia Museum of Art, 1973), p. 295.

13. Leo Steinberg, "Jasper Johns: The First Seven Years of His Art," in *Other Criteria: Confrontations with Twentieth-Century Art* (London and New York: Oxford University Press, 1972), pp. 52–53.

14. Roberta Bernstein, *"Things the Mind Already Knows": Jasper Johns — Painting and Sculpture, 1954–1974* (Ann Arbor: UMI Research Press, 1985), p. 5.

15. Jasper Johns, in Katrina Martin, dir. and prod., *Hanafuda: Jasper Johns* (film), 1980; quoted in Riva Castleman, *Jasper Johns: A Print Retrospective* (New York: The Museum of Modern Art, 1986), p. 20.

16. There is one drawing, *Sketch for Flashlight* of 1958 (illustrated in Nan Rosenthal and Ruth E. Fine, *The Drawings of Jasper Johns* [Washington, D.C.: National Gallery of Art, 1990], p. 148), that precedes the sculpture *Flashlight I* of the same year, as well as two light-bulb drawings: one in 1957 — of a hanging light bulb for a sculpture that was not executed until 1969, as an editioned lead relief — and one in 1958 that followed *Light Bulb I.*

17. Jasper Johns, interview (1965) published in David Sylvester, *Jasper Johns Drawings* (London: Arts Council of Great Britain, 1974).

18. Bill Goldston of ULAE recalls that Johns finished the second cast of *Painted Bronze* before his trip to Japan in 1964 but did not complete the lithograph until after his return.

19. Although Johns completed over forty-five prints between 1960 and 1963, *Ale Cans* is the only published print in 1964.

20. When asked about the coincidence of his printmaking and sculpting activities, Johns denied any concrete connection.

21. Castleman, *Jasper Johns: A Print Retrospective,* p. 18.

22. There is a 1960 charcoal drawing of the same composition, made after the encaustic painting of the same year.

23. Richard Field, *Jasper Johns: Prints, 1970–1977* (Middletown, Conn.: Davison Art Center, Wesleyan University, 1978), p. 8.

24. Johns's working proofs engendered an important exhibition in 1979 titled "Jasper Johns: Working Proofs," organized by Christian Geelhaar at the Kunstmuseum Basel; see Geelhaar, *Jasper Johns: Working Proofs* (Basel: Kunstmuseum Basel; London: Petersburg Press, 1979). The working proofs for *Ale Cans* were included in that exhibition.

25. For a detailed discussion of Johns's various drawing mediums, see Ruth E. Fine's essay "Making Marks," in Rosenthal and Fine, *The Drawings of Jasper Johns.*

26. Johns, interview with the author.

27. Illustrated in d'Harnoncourt and McShine, eds., *Marcel Duchamp,* p. 272.

28. See Geelhaar, *Jasper Johns: Working Proofs,* p. 65.

29. See Riva Castleman, *Jasper Johns: Lithographs* (New York: The Museum of Modern Art, 1970).

30. This piece is illustrated with its original annotation in Geelhaar, *Jasper Johns: Working Proofs,* plate 2.8. A further indication of the importance to the artist of the accuracy of these annotations is a note from August 24, 1985, that Johns wrote to The Museum of Modern Art to check if one of these proofs was correctly marked as a "working proof" and not as a "trial proof." He wrote that he had already changed one of them.

31. The use of the rectangular framing device can be seen in some of Johns's early drawings as well, such as *Figure 1* (c. 1959); illustrated in Rosenthal and Fine, *The Drawings of Jasper Johns,* p. 123.

32. When the print was published, it was titled *Beer Cans.* By the time the first volume of Richard Field's catalogue raisonné appeared, in 1970, the title had been changed to *Ale Cans,* accurately reflecting the cans' labels.

33. See the photo-engraving in the portfolio *1st Etchings, 2nd State,* mentioned below.

34. This is not Johns's first use of photography in his printmaking. *Pinion* (1963–66), *Passage I* and *Passage II* (both 1966), and *Voice* (1967) incorporated photographic images, taken from earlier paintings, into the composition.

35. For a detailed discussion of the evolution of the prints and paintings of *Decoy,* see Roberta Bernstein, *Jasper Johns Decoy: The Print and the Painting* (Hempstead, N.Y.: Emily Lowe Gallery, Hofstra University, 1972).

36. "Interview with Jasper Johns" (1978), in Geelhaar, *Jasper Johns: Working Proofs.*

37. Field, *Jasper Johns: Prints, 1970–1977,* p. 42.

38. Illustrated in Bernstein, *Jasper Johns Decoy,* n.p.

39. Johns, interview with the author.

40. For a detailed description of the *Ale Cans* drawings of the 1970s, see Rosenthal and Fine, *The Drawings of Jasper Johns,* pp. 154–57.

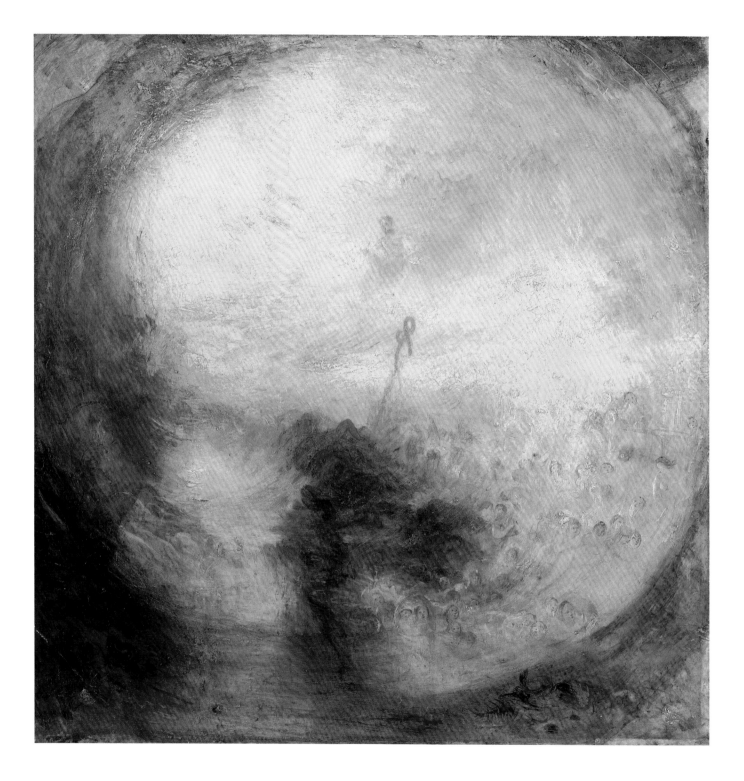

1. J. M. W. Turner. *Light and Colour (Goethe's Theory) — The Morning after the Deluge — Moses Writing the Book of Genesis.* exh. 1843. Oil on canvas, 31 x 31" (78.5 x 78.5 cm). Tate Gallery, London. The Turner Collection

The Precursor

John Elderfield

The meanings are our own —
It is a text that we shall be needing. . . .
 Wallace Stevens[1]

In 1966 — the Minimalist year, which saw "Primary Structures" at The Jewish Museum and "Systemic Painting" at the Guggenheim[2] — The Museum of Modern Art held an exhibition that proved to be the most popular in its then thirty-seven-year history. The subject of the exhibition was the paintings and watercolors of Joseph Mallord William Turner, 1775–1851.[3]

In the catalogue for "Turner: Imagination and Reality" — explicitly in the foreword by Monroe Wheeler and implicitly in the critical essay by Lawrence Gowing — Turner was offered as a precursor of contemporary abstract painters, in particular those "whose principal means of expression is light and color."[4] Earlier, the Museum very exceptionally had devoted exhibitions to "other periods of art history in which the modern spirit happened to be foreshadowed or by which modern artists have been influenced."[5] But there was "no precedent for a one-man show of an artist who died more than a century ago." So, why Turner?

Precursors of modern art have worn a surprising variety of guises and have preached many creeds. Always, however, they have served two interrelated functions: first, to contemporize the historical and, second, to historicize the contemporary.

First: "Turner died a hundred and fifteen years ago, but some of his pictures look as if they were painted yesterday," the Museum's press office asserted.[6] His art "astounded and bewildered his contemporaries," said Gowing, "and is still not altogether comprehensible today."[7] If these two claims are true, the work of Turner is continuous with today's incomprehensible art. Thus, Turner becomes a contemporary painter, at one with the painters who derive from him; one of that group. For the historical and the contemporary are thereby equal in the present, equally ahistorical: a Turner (fig. 1) looks as much in imitation of a Pollock (fig. 2), let us say, as a Pollock looks in imitation of a Turner.[8]

Contemporization of the historical can be achieved by purely conceptual

2. Jackson Pollock. *The Deep*. 1953. Oil and enamel on canvas, 7' 2³/₄" x 59¹/₈" (220.3 x 150.2 cm). Musée National d'Art Moderne, Centre Georges Pompidou, Paris. Given in memory of John de Menil by his children and the Menil Foundation

recontextualization; that is to say, purely by arguing (or by asserting) that Turner is in effect a contemporary. In the case of the Turner exhibition, however, the effect was reinforced by *literal* recontextualization: not only by moving historical pictures into a modern museum but also by removing them from behind glass and from their elaborate historical frames into more modern moldings,[9] and by displaying them on severely bare walls with a sleek, Plexiglas-topped barrier in front (fig. 3). The Turner shown at The Museum of Modern Art in 1966 is therefore presented as if he were a contemporary

3. Installation view of the exhibition "Turner: Imagination and Reality," The Museum of Modern Art, New York, 1966

artist; that is to say, in imitation of a contemporary artist. So we now have another question to answer: What is the real identity of this contemporary artist called Turner?

The second function of a precursor, I said, is to historicize the contemporary: "These pictures, from the last twenty years of Turner's life, revealed potentialities in painting that did not reappear until our time," claimed Gowing and Wheeler.[10] But is it not true also to say that our painting revealed potentialities in these pictures that did not appear in Turner's time? Of course, the novelty of Turner's late pictures was noticed when they were made. Nevertheless, to choose to exhibit in 1966 at The Museum of Modern Art thirty-seven late oils and only two early oils is unquestionably a critical judgment of Turner influenced by contemporary art.[11] Not any Turner will do. It must be a particular Turner.

This is most easily demonstrated, in fact, with reference to the two early oils that were chosen. The early Turner had to be represented in some form because "one cannot separate an artist's late work from the rest; its meaning unfolds throughout his life."[12] Not to include early Turner would be to disrupt the idea of continuity between early and late, between past and present: the whole idea of the exhibition. It need only be a token representation, and preferably should be, lest attention be drawn away from the late work. It does, however, have to make the right point. And here, the wrong point very nearly was made.

The original proposal was to have just one early work, the highly the-atrical *Fifth Plague of Egypt* (fig. 4). However, as Gowing eventually realized, this picture alone would give "quite a false idea of Turner's starting point. It emphasizes the aspect of the Sublime but doesn't give the opposite point of view which is equally important."[13] In other words, it overemphasizes the dra-matic and rhetorical in Turner. So a second early work was added, the more lyrical *Buttermere Lake* (fig. 5), where "the paint itself" was as real to the artist, claimed Gowing, as what it represented.[14] Thus early anticipates late which anticipates still later, namely the contemporary:

Now we find that a kind of painting, which is of vital concern to us, was anticipated by Turner. And by Turner alone. . . . Turner showed that a certain potentiality was inherent in the nature of painting. The latent possibility has emerged again.[15]

The contemporary is thus historicized, returned to the moment of Turner's death to pick up where Turner left off. (Gowing's catalogue essay appropriately concludes with a lengthy description of a posthumous invento-ry of Turner's studio.)[16] So, a Pollock, let us say, is really an extremely late Turner. Simultaneously, the continuity of past and present is confirmed — and with it the idea of artistic progress as unfolding within, not against, tradi-tion — and the antagonism of the avant-garde is ameliorated as it gains a respectable paternity. A wonderful premise for a successful exhibition. But still: Why Turner? And what is his real identity?

In 1966, nobody could agree. The arrival of the loans from London on the S.S. *United States* on March 4 was announced in the *New York Times* with the explanation that Turner's "revolutionary works . . . are regarded by many art historians as precursors of French impressionism."[17] But that, surely, would not bring them to The Museum of Modern Art. The organizers of the exhibi-tion said that the Turners "tell us something about the inner nature of a

Left:
4. J. M. W. Turner. *The Fifth Plague of Egypt.* exh. 1800. Oil on canvas, 49 x 72" (124 x 183 cm). The Indianapolis Museum of Art. Gift in memory of Evan F. Lilly

Right:
5. J. M. W. Turner. *Buttermere Lake, with part of Cromackwater, Cumberland, a Shower.* exh. 1798. Oil on canvas, 36 1/8 x 48" (91.5 x 122 cm). Tate Gallery, London. The Turner Collection

whole pictorial tradition, of which recent American painting is an integral part."[18] But they did not say, precisely, which pictorial tradition and which examples of recent American painting they had in mind. It was clear, nonetheless, that there were associations to be found between Turner and contemporary painters; also that these associations came as a revelation to many visitors to the show. Even at the preview, reported the *Herald Tribune,* "guests, numbering in the thousands, walked through the Museum as if in a daze."[19] When the exhibition opened, the Museum's (then much smaller) galleries were thronged with some 5,200 visitors a day and opening hours had to be extended. In its twelve-week run, it was seen by nearly 400,000 people and over 68,000 catalogues were taken home (extraordinary figures even for today).[20] And the press was almost unanimous in its ecstatic praise. Turner, it was clear, was "our contemporary."[21] But still, nobody could agree why.

"In the rampant confusion besetting the world of art, the Turner exhibition at the Museum of Modern Art proved to be the source of still more confusion," wrote Dore Ashton in her "New York Commentary" for *Studio International,* summarizing reactions to the exhibition for the benefit of the artist's countrymen:

It loosed a deluge of speculative commentary which alternated between a beard-stroking pontificating about Turner's revolutionary role in the history of modern art and frantic appeals for "re-evaluation." Of course, Americans have always vacillated, now rejecting the past with fervor, now annexing it indiscriminately to justify the present. But the Turner show seemed to have roused them beyond all previous exhibitions of so-called precursors, and they have filled the press with resounding essays.[22]

Ashton went on to quote from conflicting *New York Times* reviews of the exhibition by John Canaday and Hilton Kramer. Canaday, in fine curmudgeonly form, said it would be easy to "string along with the thesis of the Museum's show, which seems to be that Turner could not have been such a bad painter after all, if in his grandeur more than a hundred years ago he could anticipate the anemia of experimental painting in the 1960s." He was "weary of the parasitism . . . [of] *avant-garde* abstract painters in this country today . . . [who,] busily celebrating the ABC's of art under a camouflage of aesthetic gibberish, suck support from artists of the past for whom these ABC's were merely ABC's."

This seems, to say the least, a somewhat heated reaction to an exhibition of Romantic landscape painting. Until we learn two things Ashton neglected to explain: First, the ABC's that so incensed Canaday refer to an article by Barbara Rose published in *Art in America* in October–November 1965, a few months before the opening of the Turner exhibition.[23] The article was called "ABC Art" and was one of the first extended discussions of Minimalism, which Rose described as an art of "blank, neutral, mechanical impersonality"

6. J. M. W. Turner. *Reflecting Metallic Spheroids* (detail). c. 1820–28. Oil on paper, 25 x 38 1/2" (63.5 x 97.8 cm). Tate Gallery, London. The Turner Collection

reacting against "the romantic, biographical Abstract-Expressionist style which preceded it" and which she understood to derive ultimately from the work of Malevich and Duchamp. More precursors. But hardly anything to do with Turner.

Second, however, the Turner exhibition contained these oddities: an oil on paper of *Reflecting Metallic Spheroids* (fig. 6) and a pair of *Colour Diagrams* in watercolor (fig. 8).[24] The oil on paper showed the windowed interior of Turner's room reflected on the convex surfaces of three polished spheres, which also reflect each other. "Such images were demonstrably composed of light, and they were colored by the medium in which they were seen," wrote Gowing, adding: "The idea that images could possess an inherent shape, and one that was not rectangular, reappeared many years later in some of his most original pictures."[25] The watercolor comprised two diagrams, each representing three superimposed triangles of different hues surrounded by a circular rainbow. "These are the first diagrams of their kind by any artist of standing that we know . . . ," wrote Gowing. For Turner "the theory of color held a profound imaginative richness. . . . Turner looked at the intrinsic visual character of painting with a directness that anticipated the studies of modern painters."[26]

So there we have it. The *Reflecting Metallic Spheroids* look as if they could have been in the Modern's 1965 "The Responsive Eye" exhibition (fig. 7);[27] the *Colour Diagrams* in the Guggenheim's "Systemic Painting." (fig. 9).[28] These curiosities of Turner's certainly were noticed. But they were greeted with some skepticism. "Possibly the current exhibition aims at the establishment of new kinships," wrote Robert Pincus-Witten in *Artforum*, kinships between Turner and "artists working in the vast Duchampian legacy, notably a whole school of Diagramists" and "color-field painters of purely retinal and surface appeals."[29] He did not sound convinced. Dore Ashton asked some painters what they thought: "They tend to laugh at the attempts of the critics to make Turner's color notations in his watercolor book prototypes of modern abstract experimentalism. Any artist with a box of colors might have done the same thing, they feel."[30]

7. Enzo Mari. *Dynamic Optical Deformation of a Cube in a Sphere*. 1958–63. Transparent polyester resin, 4" (10.2 cm) diameter. The Museum of Modern Art, New York. Larry Aldrich Foundation Fund

8. J. M. W. Turner. *Colour Diagrams* (details). after 1824. Watercolor on paper, 21 1/2 x 29 1/2" (54.6 x 74.9 cm). Tate Gallery, London. The Turner Collection

Canaday was right: Turner's ABC's were merely ABC's. But the exhibition also included a generous selection of extremely freely conceived late pictures, and it was in these that Canaday's colleague, Hilton Kramer, found the mark of Turner's contemporaneity in its most pronounced form. In these pictures, he observed, "Turner comes to us at the present moment as an inspired precursor of the attempt to create a pictorial style out of the materials of color alone." He continued:

It is precisely this priority of color upon which an increasing number of contemporary American painters (including two of the four who will represent the United States in Venice next summer; Helen Frankenthaler and Julius [sic] Olitski) have lately been concerned to build their entire pictorial vision. It is color liberated from the form-making authority of drawing — color conceived and executed as the sheer embodiment of light.[31]

9. Al Brunelle. *Jayne*. 1965. Metalized cellulose acetate butyrate on wood with acrylic and crystals; six panels, each 21 x 21 x 3" (53.3 x 53.3 x 7.6 cm). Whereabouts unknown

This seemed far more plausible. The Museum of Modern Art was showing Turner because he was a Color Field painter. But which one? Frankenthaler? Olitski? "During a television discussion the names of Noland and Louis were also mentioned," reported Dore Ashton.[32] "I can remember a time when Rothko and others of the Abstract Expressionist generation were used as examples of the Turner influence, relayed somehow from England." The problem, she concluded, was this:

The resurrection of fathers is a frequent occurrence here, although their moments of worship are brief. Who, these days, talks about Monet? Yet he, too, was honored by a Museum of Modern Art show not too long ago, and he too was busily worked upon so that he would satisfy a peculiar American craving for history.[33]

So each generation creates its own paternity for itself — or, as a contemporary of Turner's put it rather more eloquently, the child is father of the man.

But still, "paternity" while a selective term is not a voluntary one; just like "modernism." It is selective because it is limiting but it is not voluntary because it cannot be chosen. In the organic, developmental model of art presented by this metaphor, each artist and each work of art grows from, indeed is inconceivable without, its predecessors, which assert their immortality in the new artist and new work, even in what seems most new and most individual there.[34] The same must be true for the paternities claimed by new artists and new work. Each artistic father is, finally, the child of the father who preceded him. Turner, finally, is not created in Olitski's image, or Noland's, or Pollock's. Turner, the precursor, is created in the image of another precursor, the one whose role he supplants. The modern artists whom Turner anticipates will seem to have developed from the artists influenced by that supplanted precursor. Likewise, Turner's own art (viewed with this telescoped hindsight) will seem to comprise a development beyond that other precursor's art, regardless of their chronological places in history. Ashton, in fact, had stumbled upon the truth of the matter. Turner is modeled after Monet.

We know that he is modeled after Monet when we learn that the Turner exhibition of 1966 was originally proposed as a sequel to the Monet exhibition of 1960 by the curator of the Monet exhibition, William C. Seitz, shortly after that exhibition had opened.[35] This institutional succession, however, is but a reflection (as well as, in part, a cause) of something much broader, namely a succession of taste that brought Turner in Monet's footsteps to contemporary artistic attention as a candidate for precursor in the mid-1960s. As will soon become apparent, to consider how Turner is modeled after Monet is also, in effect, to consider what remained in the mid-1960s of Abstract Expressionism and how it was interpreted. Turner will therefore become our guide into the sensibility of the sixties; his eventual dismissal will tell us when we have arrived.

Transparent Things

Turner is modeled after and succeeds Monet, and is worthy of consideration as a precursor of contemporary painting, in these four ways. First, "he reached out into the borderline between representation and the abstract"[36] and thereby engaged the issue of making paintings that while abstracted nevertheless had subjects. Second, he overcame the contradiction of representation and abstraction by making representational paintings of what seemed to be abstract subjects; therefore, "someone said of his landscapes that they were *pictures of nothing and very like.*"[37] Third, the effect of this was to make his paintings, at their most extreme, seem not mimetic but symbolic in their representation of the external world; therefore, records of imagination rather than of reality. And fourth, all this was achieved by Turner's having "confidence in the element in painting that is involuntary and unrehearsed,"[38] that is to say, in the very act of painting itself. Let me take these points in turn.

First: Even — especially — at its most abstract, Abstract Expressionism was preoccupied with subject matter. However, its preoccupation with the border-line between representation and abstraction is associable with its admitting elements suggestive of the non-abstract.[39] That is to say, it is a phenomenon of the mid-1950s, motivated in part by the exhibition of de Kooning's six large Woman-series pictures in 1953. Thereafter, a large range of, especially, so-called second-generation artists (from Frankenthaler and Joan Mitchell to Larry Rivers and Milton Resnick) seemed to find greater freedom on the abstraction-representation borderline than in either abstraction or representa-tion: a greater freedom of action in the improvisatory creation of art and a greater freedom of potential meaning in the ambiguity of the result.

Many painterly, *malerisch,* artists of the past could be — and were — admired for having embraced an equivalent freedom. But Monet was of par-ticular interest. The Monet vogue had begun earlier, in the late 1940s, and originally served to validate abstract, not abstract-representational art: the all-overness of the Impressionist field and its composition, in Monet's late works (fig. 10), from close-valued and broadly drawn areas of paint spread out over a large surface area seemed to anticipate Pollock and Color Field painters like Still and Rothko.[40] However, Monet became particularly interesting to the 1950s because abstraction and representation thus seem to be mutually re-inforcing across the entire pictorial surface as in the figuratively enriched Abstract Expressionism of that decade.

This interpretation of Monet in the context of contemporary painting was codified with the introduction of the term "Abstract Impressionist" in 1954 to refer both to the Color Field wing of Abstract Expressionism and to those second-generation artists whose work afforded associations with land-scape, to a greater or lesser degree.[41] It can be said to have culminated in the Whitney Museum's 1958 exhibition "Nature in Abstraction,"[42] and with The Museum of Modern Art's Monet exhibition in 1960. For Monet, wrote Seitz in the concluding paragraph of his catalogue essay for that exhibition, "nature had always appeared mysterious, infinite and unpredictable as well as visible and lawful. He was concerned with 'unknown' as well as apparent realities."[43] Gowing's Turner, in his catalogue essay, begins at this very point, where Seitz's

10. Claude Monet. *Water Lilies.* c. 1925. Oil on canvas, 6′ 6 1/2″ x 18′ 4 3/4″ (199.4 x 560.7 cm). The Museum of Modern Art, New York. Mrs. Simon Guggenheim Fund. Destroyed April 15, 1958

Monet had left off. Thus, "the kind of reality and the order of imagination that painting had traditionally offered were changing in Turner's time. Since his time such transformations have reoccurred with increasing frequency. We are now familiar with the disturbances that they make."[44] Turner succeeds Monet because, even more than Monet, he reached the precise borderline of the abstract and the representational. As Pincus-Witten put it, in his review of the 1966 exhibition:

Turner, long before 1850, came to grips with the 20th century's most critical question, namely, how great is the role of natural representation? Turner replied by bringing a dissolution of reality in threaded pools of tissue-thin paint as near to atomization as any figure of modern painting since.[45]

But abstraction-representation was hardly a gripping issue in New York in 1966. Even in the early years of the decade, art occupying that borderline was looking outmoded. Pop art and the new cooler abstract painting were both against what now looked like evasive ambiguity.[46] Thus, the Monet–Turner succession viewed as a continuing investigation of the abstraction-representation borderline was hardly credible in 1966. To exhibit Turner for that reason was not really to exhibit an artist of fully contemporary relevance but rather of relevance to art that had been contemporary a decade before. (This may help to explain the extraordinary popularity of the Turner exhibition; it was familiarly new.)

So what is Pincus-Witten talking about? The clue is his "threaded pools of tissue-thin paint . . . near to atomization." He is discussing Pollock, or possibly Louis; fully abstract painters. This takes me to my second point: Turner succeeds Monet in 1966 by succeeding Monet's original function as precursor of *abstract*, not abstract-representational, art. Monet had become important to abstract painting in the late 1940s for his dissolution of the sculptural in reality. In his Nymphéas pictures especially, "appearance becomes apparition";[47] and "now the unity and integrity of the visual continuum, as a continuum, supplants tactile nature as the model of the unity and integrity of pictorial space."[48] What is represented, that is to say, is not tactile appearance but something incorporeal, like a mirage. Here Turner's "pictures of nothing" could offer an even better model than Monet's pictures of water; they suggested some "primal flux which denies the separate identity of things."[49]

And, of course, Turner had chronological precedence over Monet. "Turner, really, was the one who made the first significant break with the conventions of light and dark," wrote Clement Greenberg in "'American-Type' Painting," his influential account of the anti-sculptural, optical principles he inferred from what he considered to be the most advanced of Abstract Expressionism. "In [Turner's] last period he bunched value intervals together at the light end of the color scale" and thereby anticipated both "Monet's close-valued painting" and the "volume-muffling" color in the paintings of

Newman, Rothko, and Still.[50] And yet, what made Monet rather than Turner the ideal model for the 1950s was the warmth and darkened quality of his close-valued color, which was closer to that of Abstract Expressionist painting than the coolness and lightness of Turner's watercolor-influenced late style. Additionally, Monet was an early modern School of Paris painter whose paternity could be documented. His late Nymphéas paintings of the 1920s seemed "to belong to our age"[51] and as such could be seen hanging at The Museum of Modern Art (fig. 10).[52]

However, Monet's example eventually faded. In 1966, we heard earlier, Ashton was saying that he had been forgotten, and that Turner was proposed to replace him. Monet's example had faded, we must presume, because so had the art supported by Monet's example. We know that art on the abstraction-representation borderline did fade at the end of the 1950s. But what about abstract painting?

Here, Turner's appearance in 1966 is of much greater interest, for abstraction had flourished to produce a new generation of Color Field painters, among them Louis, Noland, and Olitski, whose art was being avidly discussed at mid-decade. Was Turner's relationship to these new painters what Monet's had been to their Abstract Expressionist predecessors? So it would seem from reviews of the Turner exhibition.

Before considering Turner's relationship with these new abstract painters, however, we need to know more about his relationship with their predecessors. This brings me to my third point about the Monet–Turner succession.

Monet, as Seitz observed, "was concerned with 'unknown' as well as apparent realities."[53] In this respect, he could be seen as anticipating not only the morphology of Abstract Expressionist Color Field painting but its purported symbolic content as well. Here, however, Turner's Romanticism could serve even better than Monet's Symbolism. And in February 1961, as the Monet vogue faded, there appeared in *Art News* an article of which the reception afforded the Turner exhibition can reasonably be said to be a consequence. By Robert Rosenblum and called "The Abstract Sublime," it bore the editorial subtitle "How Some of the Most Heretical Concepts of Modern American Abstract Painting Relate to the Visionary Nature-Painting of a Century Ago."[54] Here, Rosenblum suggested "affinities of vision and feeling" between, on the one hand, Turner and other nineteenth-century artists concerned with the Sublime, such as James Ward or Caspar David Friedrich, and on the other, Still, Rothko, Newman, and Pollock.

Turner was especially important because he revealed the two opposite ways the Sublime could be attained: "by saturating . . . limitless expanses with a luminous, hushed silence" and "by filling this void with a teeming, unleashed power."[55] An example of the former approach was his *Evening Star* (fig. 11), which Rosenblum compared to a Rothko (fig. 12). An example of the

latter was his *Snowstorm* (fig. 13), which Rosenblum compared to a Pollock (fig. 14).[56] What is meant by the Sublime here, be it quiet or noisy, is not the same thing that Gowing referred to when questioning the proposed representation of Turner's early work in the 1966 exhibition; it does not carry the same explicitly rhetorical associations. Nevertheless, association of the Abstract Expressionists with what Rosenblum calls the Northern Romantic tradition does impute to their work an illustrational meaning; their art is seen as issuing from, and symbolizing, an "heroic search for a private myth to embody the sublime power of the supernatural."[57]

Certain later Color Field painters could also be viewed as heirs of Romanticism. In 1963, Rosenblum wrote of Morris Louis in these terms.[58] But by the mid-1960s, the illustrational in Romanticism, and the symbolic in Abstract Expressionism, seemed as outmoded as art on the abstraction-representation borderline. And yet, there was something in Romanticism, and

therefore in Turner, that continued to seem relevant. "The works of Pollock, Louis, Noland and Olitski," wrote Stanley Cavell at the end of the 1960s, "achieve in unforeseen paths an old wish of romanticism — to imitate not the look of nature, but its conditions, the possibility of knowing nature at all and of locating ourselves in a world."[59]

My fourth and final comment on Turner's succession to Monet as an Abstract Expressionist will take us to the new Romanticism of which Cavell speaks.

The Monet admired by the Abstract Expressionists was a painter of spontaneous, unrehearsed pictures; that is to say, a fictional Monet — not quite the dauber some of his contemporaries thought he was (fig. 15) but enough of an improvisor to anticipate Pollock (fig. 16).[60] In one section of Gowing's catalogue essay on Turner, a comparable artist appears (fig. 17); one who while

15. Cham. *Nouvelle École — Peinture indépendante.* 1870s

more secretive than anyone . . . had evidently an even stronger instinct for the nature of painting as a performance. His absorption in the intrinsic character of paint seems to have extended to the act of painting. It was as if he needed to exhibit an action as well as a picture. He gave a perennial demonstration of a quality in painting that he must have been determined should be recognized. It was like an anticipation of the recent controversy in New York about whether it is possible to hang an action on the wall. . . .[61]

The anachronism of Turner as American Action Painter is startling enough. But what makes this passage even stranger is that Harold Rosenberg's article which provoked the controversy Gowing refers to was published in 1952, some fourteen years before Gowing's essay.[62] This is yet additional evidence that part (a large part) of the appeal of a Turner exhibition in 1966 was that his pictures looked as if they were painted not, in fact, yesterday but far enough in the past to look *familiarly* contemporary.

16. Jackson Pollock in his studio, 1951. Photograph by Hans Namuth

Still, even if the exhibition recalled and reinforced the familiar, it did make fresh discoveries there — as it did not in its few obvious appeals to contemporary relevance, the systemic color studies and the images of globes shaped by their subjects' form. (There may be a lesson here for other polemical shows.) For Turner's Action Painting as presented in the exhibition and in Gowing's essay differs from Rosenberg's model of 1950s Abstract Expressionism in one very crucial respect: in the stress placed on watercolor as the liberating medium for Turner's late style. By virtue of this emphasis, Turner seems to have a great deal to do with Louis and Noland and other post–Abstract Expressionist Color Field painters who used the so-called soak-stain technique and who arrived on the contemporary New York scene around the same time that he did (figs. 18, 19).[63]

We have heard how critics of the 1966 exhibition described Turner as a precursor of soak-stain Color Field painting. But what I want to stress now is not how a Turner may look like a Color Field painting, or vice versa; nor

17. *Turner Painting One of His Pictures,* from *The Almanack of the Month,* June 1846

even how both may be perceived to have similar aims, for example "color liberated from the form-making authority of drawing," as Kramer reasonably suggested.[64] Rather, I want to stress how both may be perceived as issuing from similar working methods, how both may be perceived as purely products of their procedures, deriving their meaning explicitly from how they are made. I also want to stress how Gowing's interpretation of Turner as a kind of

Left:
**18. J. M. W. Turner. *A Wreck, with Fishing Boats.* c. 1840–45. Oil on canvas, 36 x 48¹/₄"
(91.5 x 122 cm). Tate Gallery, London. The Turner Collection**

Right:
19. Morris Louis. *Iris.* 1954. Acrylic resin on canvas, 6'8³/₄"x 8' 10" (205.1 x 269.2 cm). Collection Mr. and Mrs. Eugene M. Schwartz, New York

Action Watercolorist, exploiting the liquidity of his thinned medium and the optical vividness of its white ground, merges Rosenberg's view of Abstract Expressionism as physical enactment with Greenberg's view of it as visual disembodiment. Turner is an Action Painter who makes Modernist Painting.

As such, his relevance to the mid-1960s has to be judged in the context of Pollock's relevance to the Color Field painting of that period. For Pollock was celebrated for his technique by Rosenberg and claimed purely for its result by Greenberg. But because Turner's technique derives from watercolor, like Louis's most notably, he seems to be almost as much a follower of Pollock as Louis was; not a precursor of Pollock but a disciple. And yet, a precursor by definition anticipates. Turner must be a bridge from Pollock to what was possible.

By the early to mid-1960s, a consensus was forming that Pollock's all-over drip paintings of 1948–50 were the most important products of Abstract Expressionism and that crucial to their importance was the improvisatory means, the "automatism," of their creation and the expressive but non-symbolic, non-illustrative abstractness their automatism produced.[65] A consensus was also forming (deriving even more explicitly from Greenberg than the first) that the abstractness of these pictures was a consequence of the effect of disembodiment produced by the spread and the superimposition of their dripped skeins or lines of paint; in other words, a consequence of their revi-

sion of contour drawing, the traditional way of evoking figures, or more precisely bodies. To critics interested in new abstraction, especially to critics who had learned from Greenberg, these pictures seemed to be nothing less than "the fountainhead of an entire tradition of modernist painting";[66] and the automatisms of the 1960s deriving from them — be they based also on controlling the behavior of paint (Louis) or on controlling the format or shape it occupied (Stella) — tended also to be viewed as preoccupied with disembodiment. Louis's eschewing the tactility of the painting medium and Stella's internalization of the contoured framing edge could equally be seen as ways of disembodying or dematerializing the physical object of painting without recourse to traditional illusionism.[67]

The late work of Turner — incorporeal, atomized, and clinging like mist to the picture surface — was surely the most convincing antecedent for all of this. Monet's late paintings had dissolved the substance of things in depictions of water and its reflections. But surely, paintings that did not, or did not only, *depict* water but were actually *composed* from water offered even greater disembodiment — and comprised automatism in the Pollock tradition. The progress of Turner's career thus took him from the old, illustrational Romanticism to the threshold of the new, where "instead of the illusion of things, we are now offered the illusion of modalities: namely, that matter is incorporeal, weightless and exists only optically like a mirage."[68]

So why, then, did Turner never quite take? Once the crowds had dispersed and discussion surrounding the 1966 exhibition had subsided, he is little mentioned in the context of contemporary painting. It would be the late watercolors of Cézanne, rather than of Turner, and especially the thinly painted pictures of Matisse that became the most frequently cited precursors for 1960s Color Field painting. Turner, it seems, was simply the bridge from *Monet* to what was possible.

After Abstract Expressionism

So, why not Turner? It is a question worth asking not merely for the sake of the record. For there are some broad lessons to be learned here — about the role and function of precursors and about the interpretation of Abstract Expressionist and post–Abstract Expressionist art — which pertain to the critical experience of modernism as well as to its historiography.[69]

Among these lessons is that the extent to which precursors figure in the criticism of the 1960s is a reflection of the extent of artistic change in that decade, or at least of the anxieties such change produced, including the anxiety of wanting a known identity for the new. All novelty tends to produce a similar reaction, but to call Stella an Abstract Dadaist, as Max Kozloff did,[70] is quite different from calling a car a horseless carriage. It implies not only historical progress but a particular version of history. Stella stands at the end of a partic-

ular version of art history which imputes to him a particular artistic identity. Michael Fried finds that identity to be "sheer fantasy" and places Stella at the end of a history in which Dada has no part. Thus each critic's "conception of the enterprise of painting in our time simultaneously depends on and entails a particular interpretation of the history of painting since Pollock or Cubism or Manet or David."[71]

Among the consequences of this position are that a critic's experience of new art will "deeply and irreversibly" alter his experience of past art, observed Michael Fried in 1966 — "so deeply and irreversibly, in fact, that his conviction is that not merely his *experience* of the older work, but, so to speak, the *work itself,* has been changed."[72] The following year, William Rubin chose as epigraph for his "Jackson Pollock and the Modern Tradition" a famous passage from T. S. Eliot's "Tradition and the Individual Talent" where Eliot tells of how "the new (the really new) work" modifies the preexisting order into which it is introduced.[73] Rubin's long essay was explicitly a reordering of the historical past on the basis of his understanding of Pollock's importance; as such, it provoked complaints that it was art-historical and not critical.[74] In 1969, Fried published his equally lengthy "Manet's Sources," in which he argued that Manet aligned himself with the past in order to consolidate then continue tradition.[75] It provoked the complaint that it was critical and not art-historical.[76] Both essays, and their receptions, exemplify the erosion in the 1960s of the distinction between criticism and art history insofar as art of the modern tradition, at least, is concerned.[77] If old and new art mutually exchange meaning, their discussion cannot be segregated; hence "the modern tradition" or, avoiding the oxymoron, the mainstream.

The continuity of the mainstream is the product of meaningful borrowing; thus the past is caused to flow into the present, even into the most individual part of a new artist's work. From Eliot's insistence in 1919 that tradition "cannot be inherited . . . you must obtain it by great labour,"[78] down to Greenberg's assertion in 1966 that "the superior artist is the one who knows how to be influenced,"[79] the past is never passively received but is chosen, and becomes part of a new work as part of its intention.[80] The mainstream (the modern tradition) therefore includes two intertwined currents: the one (modern) that joins, say, Pollock to Louis; and the other (tradition) that simultaneously joins, say, Monet to Turner. And the traditional current in the mainstream is chosen by and reinforces the momentum of the modern current. The mainstream, of course, is an organic metaphor: tradition is culture which encourages growth (not necessarily progress but irreversible succession produced by continuing improvisation). And while its traditional current, which joins its precursors, is as free from chronology as its modern current is tied to it (Turner being free to succeed Monet whereas Louis is not really free to succeed Noland),[81] the traditional current nevertheless depends as much as the modern one does upon those artists whose mission may be perceived

chronologically; that is to say, artists whose mission is to go beyond.

Thus, it used to be said that Monet had outlived himself, but in fact he went further than his contemporaries.[82] Thus, many of Turner's pictures after 1840 are balanced on a central axis in defiance of the picturesque.[83] Here lies the attraction, within modernism (and significantly, I think, within late modernism), to precursors who have identifiably late styles which do not seem as much endings as beginnings. Thus, late Monet, late Turner, late Cézanne, late Matisse, all may be perceived as paradigmatic of the wish to go beyond the established modernist past and thereby to open up a new modernist future.

It is in this context that the importance to the mid-1960s of the work of Morris Louis should be viewed. Louis's late work (he died in 1962), like the late work of the aforementioned artists, did not "seem to mark a close"; but additionally it comprised Louis's *earliest* work — "the first paintings in Louis's career" — to engage with developments that opened "to the concerns at work in the most important painting of the past several years."[84] Thus, he was at once precursor and contemporary; at once old and new. "Louis is the really interesting case," observed Frank Stella in an interview published in 1966. "In every sense his instincts were Abstract Expressionist, and he was terribly involved with all of that, but he felt he had to move, too." Stella's "all of that" was "the old values in painting" persisting in Abstract Expressionism, mainly the idea "that there is something there besides the paint on the canvas." The new idea, in contrast, can be summed up in Stella's slogan, "What you see is what you see."[85]

To move after Abstract Expressionism and to do so by shunning illustrational content: these mid-1960s aims that made Louis important made Turner unimportant. Whereas Louis's early Veils (fig. 19) seemed continuous with Abstract Expressionism, and with Turner, his late Stripes (fig. 20) began to move on beyond these old values, as did the work of Noland, Olitski, even Frankenthaler in the 1960s. The surface itself, not transparent depth, was the source of their meaning.

It was precisely the strain of transcendentalism in Abstract Expressionism that now seemed anathema. Rubin's 1967 essay on Pollock is thus symptomatic of its moment in setting out to correct overemphasis on the artist's "Romantic" side by showing that Pollock was also, and more importantly, a "Classical" artist.[86] And Pollock's growing importance was attributable in part, and possibly in large part, to the fact that, increasingly, his art seemed simply unavailable to serious discussion in Romantic terms, in terms of symbolic or illustrational content. (In contrast, Newman's importance eventually declined because it attracted such discussion.)[87] Pollock had overcome the Romanticism of his early work. Louis, in his own way, had done the same. And so, of course, had Cézanne.[88] While Matisse, best of all, had been "cold, undistracted, and full of arrogant purpose" from virtually the start.[89]

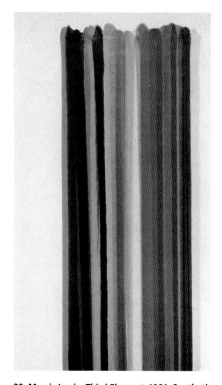

20. Morris Louis. *Third Element*. 1961. Synthetic polymer paint on unprimed canvas, 7' 1³/₄" x 51" (207.5 x 129.5 cm). The Museum of Modern Art, New York. Blanchette Rockefeller Fund

Jim Dine and Performance

Joseph Ruzicka

During the heyday of Happenings, the young Jim Dine staged four performances in 1960, marking his first sustained engagement with the New York avant-garde. Much of his work of the ensuing decade came out of the highly energetic yet ambivalent dialogue that resulted; it was ambivalent in the sense that, while Dine was always attuned to adventurous thinking, he nonetheless remained aloof from every movement and chafed at being labeled a member of any particular group. By focusing on his work in the performing arts, from the Happenings to his stage adaptation of Oscar Wilde's *The Picture of Dorian Gray* (1967–68), we can achieve a clearer understanding of his ambiguous struggle with the avant-garde and his quest to discover his own identity as an artist.

Dine himself once noted, "I did arrive full-blown in a certain way."[1] When he came to New York in late 1958, he possessed boundless energy, manual dexterity, and, most important, the conviction that he was always meant to be an artist.[2] But, as he has also said, he was "psychologically young and emotionally immature," and had not yet developed the confidence to set out on his own.[3] In an attempt to orient himself, to establish some intellectual bearing, he undertook a decade-long conversation with various avant-garde styles, working with one, then discarding it and moving on to another. The resulting work was often brilliant and always idiosyncratic.

Since his student days in Cincinnati, Dine had keenly followed the development of avant-garde art, then Abstract Expressionist painting, by reading art magazines and making periodic trips to New York.[4] He has commented that he is by nature "an expressionist thinker," but at this stage in his life, in the late fifties, it was an unfocused — and therefore adaptable — expressionism; if he had once been interested in working in an Abstract Expressionist style, he was nonetheless later drawn into the new art of Happenings and Environments, which he discovered soon after arriving in New York: "I was aware of the fact that I was of another generation. Different things were happening then, and I got involved with them. What Kaprow was saying appealed to me, so I went along. Happenings were not all that I wanted to do, but were what I was locked into by time and events. It was expected of an energetic young man with talent."[5] Dine met Allan Kaprow and Kaprow's students through the Reuben Gallery and the Judson Gallery in late 1959 and early 1960. He was

very quickly in the thick of things and in 1960 played a major role in several evenings of Happenings by Claes Oldenburg, Robert Whitman, Al Hansen, Red Grooms, and Kaprow.

But before he tackled the logistics of a Happening, Dine first learned how to deal with the problem of making a room-size work of art in his Environment *The House* — his half of a two-man installation that included Oldenburg's Environment *The Street* — which opened at the Judson Gallery in late January 1960.[6] Dine's Environment issues directly from his assemblages of the previous year, such as *Household Piece* (fig. 2), work taking both its subject matter and material from the streets of New York's Lower East Side. Two distinct expressionistic currents run through a work like *Household Piece*. First, the fact that it is made from other people's discards means the piece, when completed, already has a very rich and complex history. Previous owners inevitably impressed their own lives onto their possessions through repeated use,[7] and the assemblage becomes, therefore, a complex interweaving of many different lifetimes. Second, Dine's handling of the material clearly reflects his interest in the gestural power of Abstract Expressionist painting.[8] Moreover, by virtue of his deliberately crude handling of the material in *Household Piece*,[9] and the irregular shape of the piece, Dine made a significant break from the rigid corners and edges of the traditional rectangular format. The natural next step, then, was to transform, both spatially and emotionally, the white walls of an entire room (*The House*, fig. 3) by accumulating even greater piles of fragments from the lives of others: cloth, cardboard, household items, grocery signs, and painted cutouts of figures.

The House was a transitory work of art that could be experienced only until the end of the exhibition, when it was dismantled and destroyed. This attitude toward art as something passing and non-salable of course formed the basis of all Happenings, Dine's included. His first, *The Smiling Workman* (fig. 4), was performed the evenings of February 29 and March 1 and 2, 1960, on a makeshift stage within *The House*.[10] Wearing a floor-length smock and with a red-painted face, Dine stood behind a table that supported buckets of paint, acting out

2. Jim Dine. *Household Piece*. 1959. Assemblage: wood, canvas, cloth, iron springs, oil and bronze paint, sheet copper, brown paper bag, mattress stuffing, and plastic, 54 1/4 x 44 1/4 x 9 1/4" (137.7 x 112.4 x 23.5 cm). The Museum of Modern Art, New York. Gift of John W. Weber

3. Jim Dine in his Environment *The House*, shown at the Judson Gallery, Judson Memorial Church, New York, January–March 1960

in any other of his performances, by having them sit in the middle of the action, he did not ask them to join in the performance (as others in their Happenings increasingly did).[41] Moreover, to his mind, the spatial organization of the Happening was based on principles familiar from theater-in-the-round (albeit a liberal adaptation). It was never his intention to revolutionize the performance space, nor to draw the spectators directly into the action.[42] He wanted to keep a clear line of demarcation between life and art.

For the first time, Dine fully exploited the formal and dramatic possibilities of stage lighting, deploying spotlights, flashlights, and overhead house lights for a variety of effects. Beginning the performance, the woman-dressed-as-a-man (Judy Tersch) and the man-dressed-as-a-woman (Marcus Ratliff) pursued the car (Dine) throughout the darkened set with flashlights, occasionally striking Dine with beams of light, reliving collisions, making Dine — the struck automobile — react in fear and pain (fig. 6). Whenever an action required special emphasis, such as Pat Oldenburg's rambling, nonsensical monologue, Dine spotlit the person, leaving the rest of the performance area in darkness. And at selected times when all four performers were interacting, the house lights came up, such as when Dine stood at a chalkboard obsessively drawing and redrawing the same automobile while the other per-

8. Jim Dine. *Car Crash*. 1960. Clothing, tar, and oil paint on two burlap panels, 60 x 63" (152.4 x 160 cm) overall. Private collection

9. Jim Dine. *The Crash, No. 3*. 1960. Lithograph; sheet, 29 7/8 x 22 1/8" (75.9 x 56.2 cm). The Museum of Modern Art, New York. The Associates Fund in honor of Riva Castleman

formers stood still and grunted (fig. 1). The complexity of the lighting effectively underscored the ambitious scope of the action.

Quite different in character was *The Shining Bed* (fig. 10), Dine's final Happening of 1960, and his last for nearly five years. In establishing the space of this performance — the stage itself was a foil-wrapped bed, surrounded by the front row of seats — Dine interpreted theater-in-the-round much more traditionally than he had in *Car Crash*. And he mounted this production much more economically, wishing "to do something more modest in scale than *Car Crash*."[43] Gone were the elaborate flats and props. In their stead, he emphasized a single object (here the bed), a development of special significance for his paintings and performances. This marked a definite shift in his thinking as he distilled and simplified his work in all mediums, reining in his expressionist tendencies for the next several years, a change visible in the work of many other artists as well.[44]

To complement the simplified set in *The Shining Bed*, Dine also simplified the lighting, by focusing one overhead light on the bed. In doing this, he created a cell in which he acted, an area of light circumscribed by the darkness that enveloped the audience. This method of defining units of space through concentrated light became a tool that Dine would use to great advantage five years later in his next and last Happening, *Natural History (The Dreams)*, of 1965, in which he spotlit different groups of people spread across an otherwise darkened stage.

In *The Shining Bed*, Dine turned away from the explicit subject matter and energetic action of *Car Crash* to a more allusive and poetic performance.[45] Dealing with the idea of transformation, he performed, dressed as a blue-faced Santa Claus, either lying on the bed under covers of brown wrapping paper or plastic, or sitting on the bed.[46] At one point, he whitened his face in

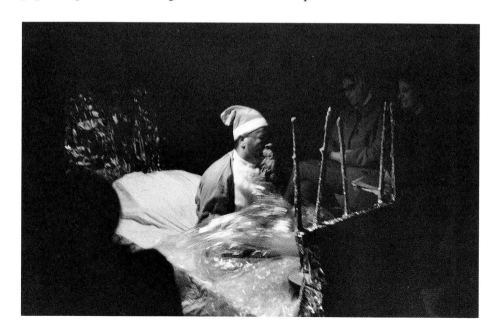

10. Jim Dine in his Happening *The Shining Bed*, performed at the Reuben Gallery, New York, December 16–18, 1960

a bowl of flour. At another, he coated foil spikes on the bed's footboard with batter, making them seem no longer like metal. For the finale, he substituted for himself on the bed a small golden doll. The entire Happening progressed through a series of physical changes that redefined Dine's appearance and restricted surroundings, and thus his identity.

Change was the most appropriate issue for Dine to grapple with in *The Shining Bed,* for after it he changed direction, leaving the stage for several years. While he certainly felt that his participation in Happenings was important for him,[47] he never thought that they would make easel painting obsolete, as Kaprow had predicted they would.[48] In fact, Dine stopped doing Happenings in large part because he wanted to devote more time to painting.[49] He never considered Happenings, his own at least, as being revolutionary. He saw them as a fusion of "painter's theater"[50] (insofar as the visual aspects accorded with what he was working on in his paintings)[51] and a "very personal psychodrama"[52] as he acted out aspects of his private life in public. This personal record of his life was enacted using the techniques and general form of traditional theater.[53] From his first engagement with the New York avant-garde, he made of its practices what he wanted, reshaping them to his own personal vision, and did not adhere to them as dogma.

If the relative simplicity and purity of *The Shining Bed* suggested that Dine was moving toward a more measured expenditure of energy, after that Happening he declared that he needed "a renunciation to get clean."[54] This change in direction was both emotional and aesthetic, and was fully evident in his Environment of early 1961, *Rainbow Thoughts,* which bore no resemblance to *The House* but rather embodied his new, economical vision. In a small room painted black, a six-inch-wide rainbow hung suspended from the ceiling, illuminated only by a single blinking light bulb. Confronted with such a stark situation, viewers had few options other than turning their attention back onto themselves.[55] In the short span of a year, Dine narrowed his focus to a select group of objects, things mostly from his own personal world, rather than things indiscriminately gathered from the world at large. The new restraint and clarity of *The Shining Bed* and *Rainbow Thoughts* set the tone for his work of the next several years. He gradually imposed a relative calm (relative because he never fully curbed his expressionist tendencies) on both his handling of materials and the heated emotions that works such as his Happenings conveyed.

One reason Dine retreated to his studio was to concentrate on his painting. Another was to remove himself from any sort of stage, to shed his identity of performer and to attend more closely to what it meant to be a serious and disciplined artist, a creator of permanent objects. This need to turn from his performance past meant that he also had to turn from his performance cronies. Many of them did not understand why he stopped performing and

felt that somehow he had sold out. After 1960, he withdrew from the society of his fellow visual artists and more and more sought the company of literary people.[56] But he nonetheless maintained a dialogue with the newest ideas of the time, over the years creating work that variously interpreted Pop art, Minimalism, and hard-edge abstraction in a very personal manner.

Dine's last Happening, *Natural History (The Dreams)* (fig. 11), opened the month-long "First Theater Rally: New York," in May 1965.[57] After being away from the stage for five years, he was persuaded to return by Alan Solomon, one of the organizers of the rally and an early champion of the artist. What ensued proved to be a most unpleasant clash of personalities. This was one of several unfortunate incidents occurring at mid-decade that drove Dine away from New York for many years.[58]

 Natural History was decidedly larger in scale and more polished in form than Dine's previous performances, and in this sense was in keeping with the

11. Bob Brown and Nancy Fish in Dine's Happening *Natural History (The Dreams)*, performed at the RKO theater at West 81st Street and Broadway, New York, May 1–3, 1965

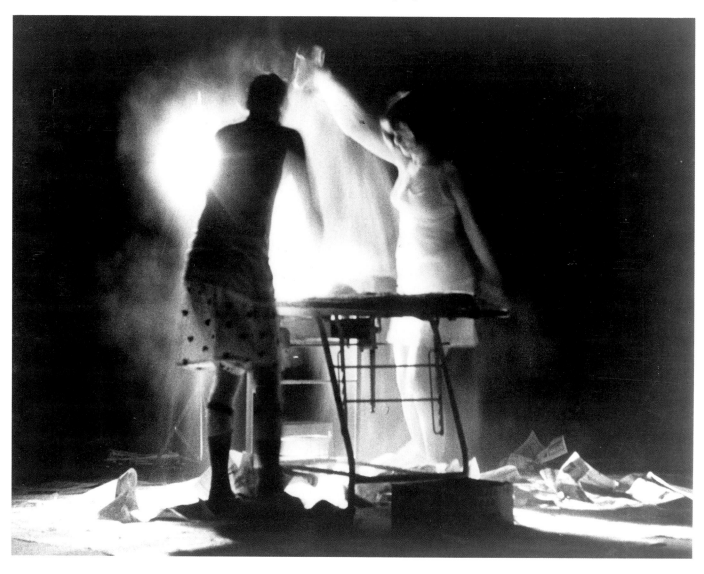

character of the other rally performances. Indeed, the ambitions behind the rally were announced by the fact that it was not staged in an alternative space on the Lower East Side, the hub of such activity earlier in the decade, but was moved uptown, to an RKO theater, complete with permanent seats and a large stage. Nonetheless, *Natural History* was markedly introspective and physically inactive when compared to both his earlier performances and the other rally pieces, most of which were exuberant physical displays making the most of the vast stage space. It was this inwardness that so disappointed the organizers of the rally, who had been anticipating something more on the order of *Car Crash*,[59] something entertaining and exciting.

Dine's last Happening was based on his dreams from the summer of 1963, a shift in subject matter from life's events to the workings of the inner mind. These were thoughts Dine mulled over for several years before acting them out, instead of performing them in skits with a minimum of preparation, and the result was a much more considered and controlled performance. Equally important, he had been in therapy since 1962, redirecting the focus of his thinking inward. One consequence of this was that the Happening dealt with insomnia, sleepless nights surrounded by a whirl of images from the semiconscious mind.

Wearing all black, slouched in a black chair in the middle of the stage, in his cell of light, Dine was flanked by four groups of performers (two on each side) simultaneously acting out his dreams, each group's cell defined by a blinking light: repetitive, everyday, almost unconscious actions, giving rise to irrational situations. Three seated, nattily dressed women exchanged items from their purses; a man and a woman in their underwear kneaded bread dough and shredded newspaper on a medical examination table; a man in a chef's uniform sawed a steel pipe; two men in tennis attire snacked while watching television. Throughout the performance, a tape recording was played of Dine reading from a book of dreams he had composed in 1963 — his brooding, late-night thoughts made audible — while he silently sat amid the four groups and smoked, or stood and shuffled around the stage, all the while plagued by visions.[60] Dine was isolated, engulfed by semidarkness, unable to dispel the random thoughts and incongruous images swirling around his brain.

From 1966 to 1969, Dine did not paint and only rarely sculpted or drew, in part because his dealer, Sidney Janis, claimed that Dine owed him money and Dine did not want to give him paintings as payment,[61] but also because, for him, painting had lost its relevance.[62] So he turned to writing poetry, designing stage productions, illustrating books, teaching, and making prints on a more intensive schedule — all pursuits requiring contact with other people, expanding his horizons well beyond the confines of the art world. During these years, he sought the company of people who were not artists and lived outside of

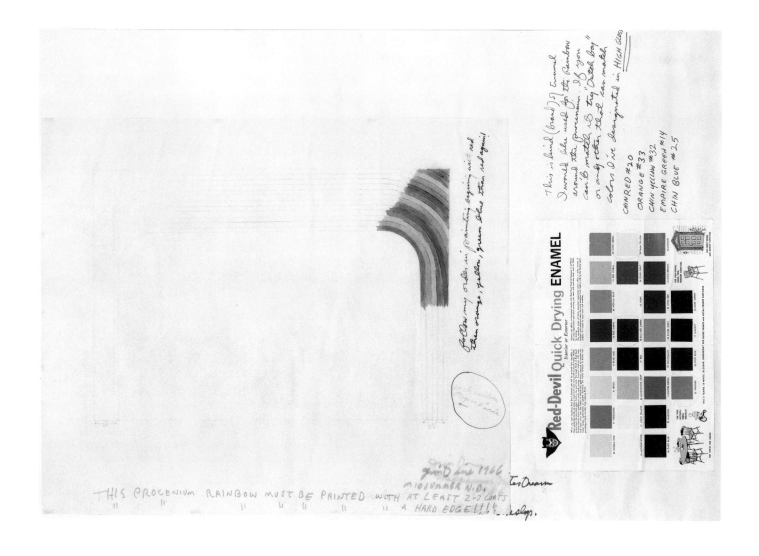

12. Jim Dine. *Proscenium Arch*
(*A Midsummer Night's Dream*). 1966.
Paint samples, felt-tipped pen, and pencil
on tracing paper, 24 x 36 1/4" (61 x 92.1 cm).
Collection Nancy Dine

New York, feeling "completely alone and out in the cold in relationship to the New York art scene."[63] Drawn to poets and writers, Dine felt that "their minds were more subtle and more receptive to what I had to say, and they were more interesting to talk to, and to relate to socially. . . ."[64] As early as 1961, he had been nervous and uncomfortable about his quickly won "notoriety" and curtailed his social contact with other artists; but the events of 1965 and 1966 finally pushed him to break off his dialogue with the New York avant-garde, even if he did not immediately have a clear idea of what to do next.

With Dine already buffeted by his experiences with the rally and with his dealer, the final break came in 1966, when John Hancock asked him to work on costumes and stage designs for a new production of Shakespeare's *A Midsummer Night's Dream* staged at the San Francisco Actor's Workshop.[65] Dine executed more than thirty drawings for the costumes, props, curtain, proscenium screen, and backdrops after conferring in San Francisco with Hancock, who then freely adapted Dine's designs as he needed, sometimes getting second ideas from the artist,[66] but generally without consultation, disregarding his carefully considered organization.[67]

Dine envisioned three distinct classes of costumes for Shakespeare's three classes of characters, and placed them in a riotously colored world of rainbows and colored quilts (fig. 12). The artisans were to wear earth-color clothes covered by the tools of their trade, bent and broken by their life of labor; the fairies, colorful and fantastic costumes declaring their existence in another realm; and the nobles, conservative and elegant attire.

When Dine designed the costumes, he saw them as a way to define the role and personality of each character, even before their first word was uttered. He found figures in *Vogue* whose poses embodied for him the essence of each Shakespearean character, traced them, then dressed them.[68] He outfitted Theseus (fig. 13), the warrior-king of Athens, in a large overcoat of black velvet over a robe, black at the top, descending through all shades of gray, to white at the bottom, marked by a venetian blind of paint chips on one side of the drawing. Dine then endowed him with the stern chin and larger-than-life presence proper to a hero, for he seems to have to crouch just to remain within the page. Lysander (fig. 15), the youth who loves Hermia against her father's wishes, stands jauntily in the middle of the page like a peacock in his multicolor satin suit, surrounded by a swirl of torn pieces of colored paper and instructions written in many colors of ink.

On the other hand, Tom Snout the tinker (fig. 14) is an inarticulate, browbeaten laborer, his face dumb and expressionless, marred by relentless hardship. Dressed in coarse brown cloth, he slumps earthward under the weight of pots and pans he is to mend, which Dine so carefully recorded. Even the white of the top of the page seems to weigh heavily upon him. By such means, Dine was able to define character not only out of color and costume, but also with the space of a sheet of drawing paper.

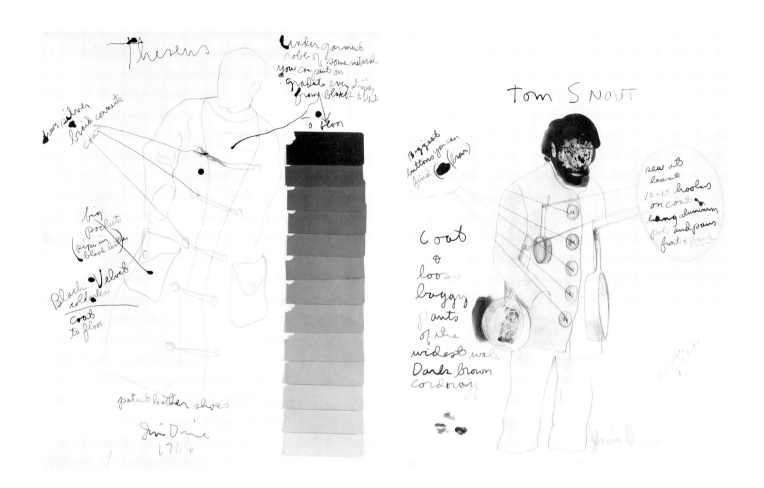

Then, in the realm of the fairies, Dine shaped a cast of fantastic characters, some whimsical, others menacing. The winged mist-green Moth (fig. 16) hovers on one foot in the middle of the page, floating in air, seemingly dancing with a lunar moth fluttering at his side. From the darker side of the fairy kingdom, rainbow-striped Puck (fig. 17), the great mischief-maker, looms large on the page like a professional wrestler, glaring out with coal-black features.

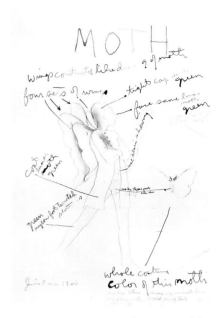

16. Jim Dine. *Moth*. 1966. Collage, crayon, felt-tipped pen, pencil, and ink on tracing paper, 16 3/4 x 11 3/8" (42.5 x 28.9 cm). The Museum of Modern Art, New York. Gift of Mrs. Donald B. Strauss

Since Dine would not appear on stage in this production, he could not use his own personal presence as a means of exploring the human condition, as he had in his Happenings; he could not himself elaborate on or refine a rough idea during rehearsal. He therefore had to pack into each drawing the physical and psychological presence that he wanted each character to carry. Dine brought to life a varied cast of characters with extraordinary efficiency and clarity by relying on his ability, cultivated since his earliest days in New York, to bring together a whole range of materials of various textures and colors: colored inks, pencil, torn paper, paint chips, glitter, and magazine illustrations. Clearly a keen observer, he used this skill to great advantage when molding his figures into distinct characters. Dine had not painted the figure since the *Car Crash* drawings. Working on *A Midsummer Night's Dream* gave him the opportunity to depict it again, and he was able to create his cast of characters quickly and assuredly. At a time when he was beginning a serious assessment of his career, this concentration on the figure — followed a year later by a similarly intensive study when he worked on a stage production of *The Picture of Dorian Gray* — had a crucial impact on his thinking, preparing for the time when he would turn to working from the figure in earnest.

17. Jim Dine. *Puck*. 1966. Watercolor, pencil, and ink on tracing paper, 14 7/8 x 10" (37.8 x 25.4 cm). The Museum of Modern Art, New York. Gift of Mrs. Donald B. Strauss

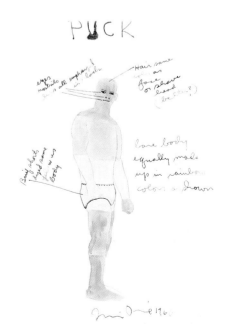

In mid-1967, to distance himself as much as possible from the New York scene, Dine moved to London for several years with his family, a change with profound implications for his future. Freed from the overwhelming pressure of being famous, of having to constantly come up with new ideas, he could relax.

Instead of reacting nonstop to others, he had time to reflect and to search for an understanding of his own identity as an artist.[69] It was during the more than three years he spent in this new place that the basis for all his work since the mid-1970s first solidified: a dedication to drawing from the figure; the full reassertion of his expressionist tendencies; a refusal to follow the dictates of certain avant-garde movements; a growing appreciation of the art of the past; and a focus on "personal private conviction rather than public."[70]

In the winter of 1967–68, Dine worked with Michael Kidd and Michael White on a stage production of Oscar Wilde's *The Picture of Dorian Gray*, a collaboration sparked by friendship,[71] something he wanted to do, not felt he ought to do. Although the production was never staged,[72] the project was a momentous beginning to his stay abroad. Most important, it was the second time in about a year that he had drawn a large number of figures. This was one of several almost clandestine encounters he had with the figure in these years, including a number of "dry-print" self-portraits he made in 1970,[73] and a large group of drawings of heads from the summer of 1971.[74] All of these occasions were informal and private and did not use the ambitious mediums of painting and sculpture, allowing Dine to avoid the pressure of the avant-garde to remain abstract.[75] In this regard, the importance of all this work rests in the seeds it sowed.[76]

In *A Midsummer Night's Dream*, Dine had worked on a large cast of characters, but in a drama encompassing only a few days in their lives. On the other hand, for *The Picture of Dorian Gray* he had to consider the development of only a few characters, but over a much broader span of time, and thus regard the effects of time and circumstances on a given person. In order to more efficiently make a large number of costumes for each of the main characters, he adopted for each a pose that succinctly summed up the major aspect of that personality, which he then retraced for each costume change.[77]

This approach worked best with Dorian, who, of course, never physically changes, but who behaves in an increasingly self-indulgent and destructive manner. Dine outlined this evolution through the use of costumes that became more outlandish as the story progressed. Thus, Dorian first appears as a naive, blond young man in a simple blue satin outfit (fig. 18), and last as a high priest of debauchery in a floor-length silver gown, with blue dust in his hair (fig. 19). Besides his pose, only his face remained unchanged in the drawings — featureless, pristine, untouched by the damage he wrought on the lives of others.[78]

In contrast, Lord Henry, the cynical dandy, never wavers in his devotion to the pursuit of pleasure, but his body pays a dear price. Aloof and aristocratic, resplendent in his brilliant costume, Henry peers with slitted eyes over his fur collar, early in the story (fig. 20). Two decades later, however, run down by his life of wanton debauchery, he is reduced to a mere description of his wardrobe: "I suit like yellow evening suit in mourning cloth no fur. I long

Left:
18. Jim Dine. *Dorian Gray's First Outfit.* **1967.** Gouache, felt-tipped pen, and pencil on tracing paper, 29 3/4 x 20" (75.6 x 50.8 cm). The Museum of Modern Art, New York. The Joan and Lester Avnet Collection

Right:
19. Jim Dine. *Dorian Gray's Last Costume.* **1967.** Gouache, felt-tipped pen, pencil, collage, and ink on tracing paper, 29 7/8 x 20" (75.9 x 50.8 cm). The Museum of Modern Art, New York. The Joan and Lester Avnet Collection

opalescent splays of color, the gleams and sheen of burnished metal, it was always to be bracketed as by-product: so much industrial trash, the ephemeral waste thrown off in the process of shaping matter. Color was a part of Minimalism's irony. There was no way it could be taken straight.

Stella's black paintings had gotten down to business. And their business had everything to do with a surface, a surface within which nothing would be ambiguous. Everything that "happened" in the picture would be the result of real manipulations of that surface. Meaning would no longer be a function of illusion, of an imagined "inside" or "behind" the surface. Meaning, since it could form nowhere but on the surface itself, would be an effect of that surface: a meaning-effect.

It was Roland Barthes who made this vocabulary of *effect* part of the post-'68 critical lexicon: reality-effect; subjectivity-effect. Both outside (the real) and inside (the subjective) lost their independent status and were seen instead as merely the "effects" of language, of a tympanum, or weave, or text, that stretched between the outside and the inside as the culturally constructed interface between the two. It was that textual surface that was "real." All the rest was only its "effect." Barthes quotes Balzac summoning up the figure of Madame Lanty in his story *Sarrazine*.[4] "Have you ever encountered one of those women whose striking beauty defies the inroads of age? . . . Their visage is a vibrant soul," Balzac writes. The effect is of Balzac remembering, referring his reader back to a reality that preexists his writing. But it is the stereotype itself, signaled by "one of those . . . ," that — formed nowhere but in the space of the writing, *in* the very surface of the textual network as one text calls to another and together they build a particular "type," endowing it with this or that special glamor — preexists the real. Insofar as it can be said that Madame Lanty "herself" is a result of this stereotype, "she" can be seen to be an effect of language, which she does not precede, but follows, imitates, copies, pastiches. The reality-effect. The subjectivity-effect.

Stella's striped pictures — black, aluminum, copper, Day-Glo — preceded, of course, the American reception of this Structuralist-based ideology of the text. So Stella's total investment of the surface as the continuum within which a logic of conventions is elaborated, conventions (like the cruciform, the star, the ring-interlock, etc.) which do not reflect meaning but, instead, generate it, had different, more local sources. Jasper Johns, for example.

Stella's stripes had evolved from Johns's Flag paintings (fig. 5), in part from the way the ready-made object had served there as a defense against "composing," against what was seen as the arbitrariness of the personal choices necessary to aesthetic structure. But in this refusal of the personal, of the inward or expressive dimension inherent to the idea of individual choice, there was also inscribed Johns's professed attention to the writings of Ludwig Wittgenstein and the *Philosophical Investigations'* skepticism about the concept of "private language." The American saw Wittgenstein challenging the

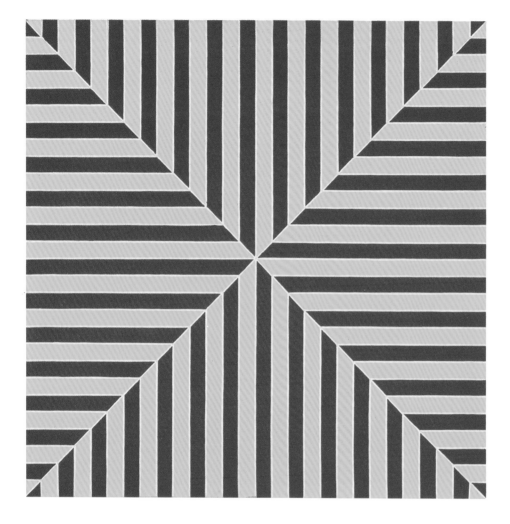

4. Frank Stella. *Marrakech*. 1964. Fluorescent alkyd on canvas, 6'5" x 6'5" (195.6 x 195.6 cm). The Metropolitan Museum of Art, New York. Gift of Mr. and Mrs. Robert C. Scull

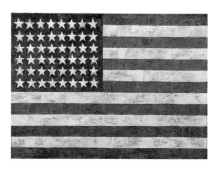

5. Jasper Johns. *Flag*. 1954–55. Encaustic, oil, and collage on fabric mounted on plywood, 42 1/2 x 60 5/8" (107.3 x 153.8 cm). The Museum of Modern Art, New York. Gift of Philip Johnson in honor of Alfred H. Barr, Jr.

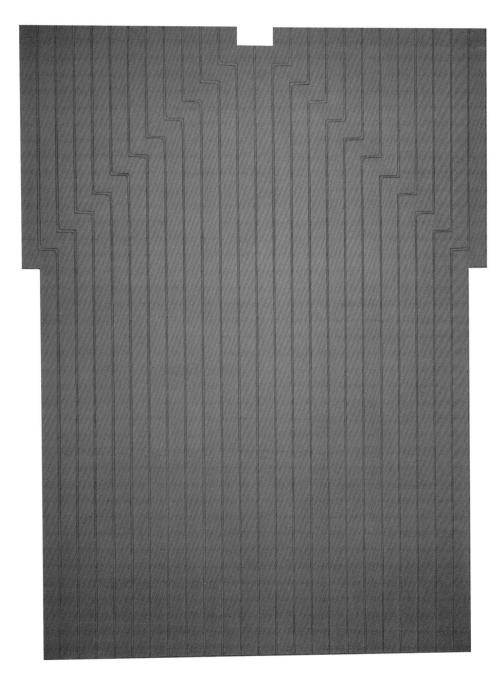

6. Frank Stella. *Luis Miguel Dominguin, II*. 1960. Aluminum paint on canvas, 8 x 6' (243.8 x 182.9 cm). Private collection

notion that, for example, when I say "my toothache," the meaning of *tooth-ache* is somehow relayed through, and thus secured by, an experience that I alone can have, an experience that is inward, private: language being an expression of this privacy. What he saw instead was a kind of linguistic behaviorism that argued that it is the conventional, public character of language that, itself, conditions feelings, constructing the illusion of inwardness: constructing what we could think of as the privacy-effect. If the armature of Johns's *Flag* was a defense against composing, it was also the means to an impenetrable surface that no amount of "expressionist" brushwork could excavate toward the putative seat of private language.

Stella did not find his ready-mades, like Johns's Flags, in the social field, but rather, in the geometrical field of the very surface he was working. As his stripes repeat the "facts" of this field, in their banal, matter-of-fact way, however, these elements begin to do something else. They begin to organize the surface in relation to that very conventional sign or symbol which is made by intersecting a horizontal with a vertical, namely the cross-sign or cruciform. This is not to say that all along a black painting like *"Die Fahne hoch!"* (see fig. 1) was a picture of a cross. It is much more to say that it is a painting that releases its viewers into an experience of the way that both cross and picture (rectangular format) are conventional forms, mutually determining each other, both of them, at their distant cultural origins, logically deduced from a set of very simple, material facts.

In these pictures Stella was able to go very far in the demonstration of the privacy-effect, both its capacity to haunt and its utter dependence on surface, as in the aluminum picture *Luis Miguel Dominguin* of 1960 (fig. 6). Departing very slightly from the regular rectangle, the work's physical shape has a notch removed from the center of its upper edge and two four-inch slices subtracted from part of its lower sides. True to form, the bands, beginning by symmetrically cupping the shape of the central notch, radiate outward. Yet, as if by magic, something of the majesty of the dead bullfighter emerges from this seemingly mechanical work, something of the mystery surrounding the fallen toreador for whom the picture is named. Once again the cruciform organizes itself, this time taking on the quality of an outstretched cape, a cape now with an added resonance as its impossible "folds" are radiant with a strange, silver light. The point, however, is that the painting is not so much an icon as a meditation on the logic of the icon, on how such a form might have come into being as a vehicle of cultural meaning.

If Stella was analyzing the surfacing-into-meaning of the icon, of the conventional sign, in canvases whose shapes determined and were determined by such signs, Robert Morris's sculpture was analyzing the body as a field which, like Stella's pictorial surface, is the external plane on which meaning occurs. In 1967 he made a group of sectional fiberglass objects, like the eight-section piece which configures a large, inert, stadium-shaped donut (fig. 7).

Going further than earlier mono-lithic objects — his three *L-Beams* of 1965 (fig. 8), for example — in its refusal of the power of geometry to legislate the coherence of the form a priori, this work refused the residual coherence given by the L-shape's armature and instead con-stituted the simple geometrical

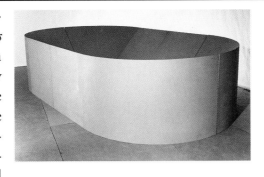

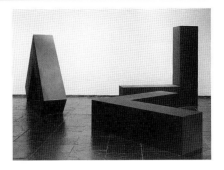

wholes from sections that fit together to make the entirety. But these sections could also be readjusted to make other forms as well. Indeed, the sectional condition of this work allowed Morris to reconfigure it differently each day of its month-long period of exhibition. And this performed a statement not just about the object's contingency, its body's surfacing-into-meaning, but also that of its viewer.

A three-dimensional, freestanding medium, sculpture naturally mirrors the body of the person confronting it, working through the identification between bodies, counting on how we sense through our own corporeal selves the meaning of this represented gesture, of that sculpted stance. No matter how abstract a sculpture may be, it nonetheless occurs in the field of the body. This had been the lesson taught by half a century of modernist "abstract" sculpture in which no matter how perfect, how crystalline the geometry of the object became, no matter how smooth the curvature of its elegant shell, in the field of meaning it always served to mirror the being regarding it. Modernist sculpture had held up a mirror of fixed, stable forms, models of rationality, of organic coherence, of technological mastery. Morris's model reflected none of these. Neither the geometry nor the meaning is fixed beforehand: no rules, no laws, no universals. And this applies to the bodies on both sides of the mirror.

2. A Tale of Two Sublimes

> *To be an artist is not a matter of making paintings at all.*
> *What we are really dealing with is our state of consciousness*
> *and the shape of our perception.*
>
> Robert Irwin

If Minimalism was characterized through this worry about surface, about the interface formed by materials as they stretched across the frame of either painting or three-dimensional object, aligning the meaning of the work with its physical medium, as that medium "surfaced," contingently, into the world, the California art of the sixties had an abhorrence of the physicality signaled by surface. The real medium of this work, John Coplans was fond of saying,

Left:
7. Robert Morris. *Untitled (Wedges)*. 1967. Fiberglass; eight sections: four, 47 x 48 x 47½" (119.4 x 121.9 x 120.7 cm); four, 47½ x 85 x 47½" (120.7 x 215.9 x 120.7 cm). Solomon R. Guggenheim Museum, New York

Right:
8. Robert Morris. *Untitled (L-Beams)*. 1965. Stainless steel; each component, 8 x 8' x 24" (243.8 x 243.8 x 61 cm). Whitney Museum of American Art, New York. Gift of Howard and Jean Lipman

9. Robert Irwin. *Untitled*. 1962–63. Oil on canvas, 6' 11 1/8" x 7' 1/4" (211.1 x 214 cm). Norton Simon Museum, Pasadena, California. Gift of the artist

10. Robert Irwin. *Untitled*. 1968. Synthetic polymer paint on metal, 60 3/8" (153.2 cm) diameter. The Museum of Modern Art, New York. Mrs. Sam A. Lewisohn Fund

Complexity and Contradiction Twenty-five Years Later: An Interview with Robert Venturi

Stuart Wrede

Stuart Wrede: I think for a lot of people, in fact a whole new generation, what happened in the fifties and early sixties is not always clear. So, if you wouldn't mind, could you reiterate the reasons why you wrote the book, and the state of architectural practice at the time?

Robert Venturi: First of all, I think one can safely generalize and say that it's very hard to understand, and very hard to remember, the recent past. It's much harder, maybe, than with the distant past. And in terms of taste, it's probably harder to *like* the recent past. For example, you might look at the wedding photograph of your parents and say, "Oh, what a funny dress my mother has on." But if you looked at the wedding photograph of your grand-parents, you'd probably say, "That's a nice dress." You can more easily like things from the distant past, because of the way cycles of taste work.

It's hard to realize how different things were then in architecture. At that time, I was a young teacher at Penn,[1] along with Denise Scott Brown, and we were the black sheep of the faculty, partly because we hadn't gone to Harvard, the sanctuary of high modern architecture. Harvard was *the* place where young people went; it was the only place to go, besides MIT. If you'd gone to Princeton, as I had,[2] where history was acknowledged — where modern architecture was very much accepted but was seen in the broad context of history, as part of a natural evolution, rather than as the end of history and the creation of a new order — well, you were looked upon as an infidel. I'm over-simplifying, but to some extent the Bauhaus approach, the modernist, pro-gressive approach, resembled that of a divinity school instead of an architectural school — the divinity school proclaims, so to speak, the final Word; and you learn by implication to be a priest rather than an artist.

I was very lucky to have been educated in a place where we weren't get-ting The Word. We were getting at what was appropriate for the time, seen in the context of the evolving past, and by implication we could evolve and grow out of the present.

Wrede: What you are suggesting is that at these other schools, year one started with the founding of the Bauhaus?

Venturi: Yes, that's right; at Princeton, architecture didn't start with the founding of the Bauhaus. And it is interesting that a historian, like Siegfried Giedion, more or less the official historian of the Bauhaus-oriented modern movement, would look at history in a highly selective way. He selected Baroque architecture and industrial vernacular architecture of the recent past as what he called "constituent facts" of history, as opposed to "transitory facts." "Transitory facts" were bad ones that didn't lead to modern architecture; "constituent facts" were good facts that did.[3]

The point is that for someone to look at history and use historical analogy, as I was encouraged to do at Princeton, and then to be inclusive in my approach was unusual at that time. So too was acknowledging a mannerist approach, rather than one involved with pure principles and pure harmony and pure progress. My method and its conclusions seemed strange.

I was hardly exaggerating when I said, at the time, that I was including in this book things I couldn't put in my theory course then for fear of the accusation I was corrupting the morals of minors. At Penn, I was doing things that were not within the orthodox tradition of modernism, of the German Bauhaus, of the rather Puritanical, New England–Gropius way of thinking.

Wrede: Your teaching was seen as subversive?

Venturi: Yes. So in a way, the book came out of feeling frustrated by the strictures of the curriculum typical of schools of architecture then. I think my theory course was the only theory course at that time in this country.

Wrede: Yale didn't offer one until you came up and taught us in 1966.[4]

Venturi: Indeed. At Penn the idea of teaching a class devoted to architectural theory originated, I'll admit, with Dean Holmes Perkins, a Harvard man par excellence and a very orthodox modernist, but he did choose it and me. Of course, now the pendulum's swung too far the other way, to the point where there is in my opinion too much theory — architecture as built theory, frozen theory, as I say. What the orthodox modernist feared has happened: you forget that architecture is a craft — that it is not sculpture but shelter.

Therefore, the book came out at a time when modern architecture was the end-all; the progressive approach was the end-all. It was a highly formalistic approach also; it did not allow for a symbolist or a mannerist view of the arts: that is, one that acknowledged ambiguity over clarity, richness over simplicity. Such a way of thinking was unusual then.

What helped me was my interest in history: my use of historical analogy,

ond one I wrote with Denise Scott Brown and Steven Izenour, *Learning from Las Vegas.* And then the idea of mixing styles, of eclecticism that can be a part of mannerism, evolves from it as well, but wasn't explicitly identified in that text.

And *Learning from Las Vegas* evolves from *Complexity and Contradiction* in another way; at the end of the earlier book, I illustrate the commercial highway and Main Street, U.S.A. (fig. 6), and I say in the seeming banality of Levittown and Main Street and in the seeming chaos of the commercial Strip, there might exist a unity and an order that we can't yet find.[8] I like the way the old book contains the germ of the new book. It is nice that I have evolved beyond *Complexity and Contradiction,* but I still feel good about it; I certainly don't wince when I look at it or think about it.

Wrede: While you were talking about the end of *Complexity and Contradiction* as a preamble to *Learning from Las Vegas,* I was struck by an amusing point about it, because in the middle of *Complexity and Contradiction* you make a reference to Times Square, which you praise, but in opposition to that, you talk disapprovingly about the banality of the roadside architecture and Levittown. You wrote:

It seems our fate now to be faced with either the endless inconsistencies of road-town [fig. 7], which is chaos, or the infinite consistency of Levittown [fig. 8], which is boredom. In roadtown, we have a false complexity; in Levittown, a false simplicity. One thing is clear — from such false consistency real cities will never grow. Cities, like architecture, are complex and contradictory.[9]

Venturi: That points out an inconsistency I was not aware of in the book; it shows an evolution in my thinking within the book and perhaps indicates an influence of Denise Scott Brown at the time, whose advanced thinking concerning American urban design and planning is not as well known as it should be.

You might also refer to the preface to the second edition of *Complexity and Contradiction,* which covers my thoughts along with Denise's at that time [1977] concerning some of the things we're now discussing as well as some of the misapplication of my ideas and the way that led to our second book.[10]

Left:
6. "Typical Main Street, U.S.A.," from *Complexity and Contradiction in Architecture,* 1966

Center:
7. "Highway, U.S.A.," from *Complexity and Contradiction in Architecture,* 1966

Right:
8. "Developers' Houses, U.S.A.," from *Complexity and Contradiction in Architecture,* 1966

Wrede: It is interesting that although you did not explicitly deal with urban design, the whole discussion of historical architecture and historical contexts in *Complexity and Contradiction* led both directly and indirectly to a new appreciation of traditional urban design in contemporary urban planning.

Venturi: That's right, and with bad as well as good results. We all suffer now as architects from having to submit ourselves to goody-goody urban-design review boards in certain municipalities and having thrown back at us in certain perverse forms the fruit of some of our earlier ideas.[11]

I might mention something that hasn't been talked about much, although Denise has touched on it.[12] The idea of context, which was discussed in *Complexity and Contradiction,* but not explicitly, and which today is central to urban-design thinking, came out of my master's thesis at Princeton of 1950.[13] My main point was that change in context caused change in meaning, an idea derived from gestalt psychology. I employed the word "meaning," as opposed to expression, a word no one had used in architecture, or hadn't used for a long time. The subject of my thesis was a chapel for the Episcopal Academy, where I had gone to school.

I remember the moment vividly in the spring of 1950 when in the library in Eno Hall (which then housed the psychology department) I found the word "context" in my reading about gestalt psychology. For me it was a true moment of discovery: "Eureka! I have found my thesis! Meaning derives from context." Today this idea has become a cliché, but it represents a valid architectural concept which for us is still basic to our aesthetic, a fundamental source for our design, and relevant in a broad way in urban design.

Wrede: How influential was Pop art on your thinking?

Venturi: Pop art was very influential. I think we have acknowledged that debt.

Wrede: In *Complexity and Contradiction* you touch on a few of the Pop art paintings of the time.[14] Did they open the door to the Las Vegas study?

Venturi: Yes, they helped open it. Pop art was important in two ways. It connected with the idea of context, where you take something familiar, put it in a new context and give it a new meaning (fig. 9): you take the Campbell's Soup can, you put it in a frame in a museum — as well as change its scale, as with Claes Oldenburg — and make of it art (fig. 10). And then, of course, Pop connected with the significance of the ordinary and the validity of convention. In this regard we were influenced by our critics as well. We presented a design for the Transportation Square office building for Washington, D.C., to the Washington Fine Arts Commission in 1968 (fig. 11), and Gordon

Bunshaft referred to our work as "ugly and ordinary."[15] We took that as a compliment; after all, Gothic and Baroque were originally derisive terms.

Wrede: Of course Pop art glorified the ordinary. But the phrase "ugly and ordinary" first appeared in *Learning from Las Vegas,* your second book.

Venturi: That's right, because "ugly and ordinary" was about reference, I think, and symbolism, more than about form. I think our building design reminded Bunshaft of ordinary things; it wasn't so much a matter of the forms of this complex building as the symbolism of it. Yes, Pop art was very important for its strong association with the ordinary. Denise knew this earlier than I did. She understood the relevance of Pop art before I did.[16] By the way, Gordon Bunshaft squelched our project, which was a very big setback for our young office.

Wrede: In *Learning from Las Vegas,* you have a whole polemic about Guild House in which you talk about "ugly and ordinary," and "ordinary and conventional."[17] But of course Guild House was designed much earlier, in 1960, and the book was published in 1972. At the time you were designing Guild House, how much did you see it as a form of polemic?

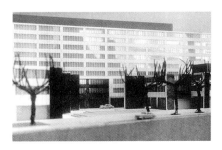

11. Venturi and Rauch. Project for Transportation Square Office Building, Washington, D.C. 1968. Model

Venturi: That's very interesting. I think if you're a good artist, most of the time what you articulate and write about you've already done. I think that's a safer stance, and that's what happened here. I first *did* the "ugly and ordinary,"

and later identified it and articulated why. It's less ideological that way. It's not saying, "I like this ideology; I'm going to make my work conform to it." I think first as an artist who has a job to do.

So you're right; I looked back and only then said, "Ah, this is 'ugly and ordinary.'" And part of the quality of the ordinary in Guild House derived from using windows — windows as holes in the wall and that contained mullions. And there's no question that using this explicit window previously in my mother's house (figs. 12, 13) was at that time shocking. I had had to work very hard to make the manufacturer insert the crossbar in the window, which was really an Arcadia sliding door. That made it, symbolically, a window. And the last thing you ever wanted to put in a late modern building was windows! Of course you employed windows, but they were camouflaged as horizontal or vertical strips in the walls via spandrels or as absences of wall. You would go to any lengths to disguise windows or abrogate them.

During the heroic period you would find holes in the walls as in Mies's Weissenhofsiedlung in Stuttgart in 1927 (fig. 14) or in Le Corbusier's Villa Savoye. But, of course, now windows with mullions are ubiquitous, from Aldo Rossi to whomever.

I think in Guild House I was glorying in being conventional for a particular reason — to make the architecture like that of the buildings where the residents had lived before. At that time a lot of poor people and some old people were being moved into housing based on European socialist ideals and images of the architectural avant-garde of the twenties and thirties. I was determined that these inhabitants were not to be forced into someone else's retardataire social revolution of which they wanted no part. So the familiar-looking building was of brick, with windows.

Left:
12. Venturi and Rauch. Residence, Chestnut Hill, Pennsylvania. 1962–64

Right:
13. Venturi and Rauch. Residence, Chestnut Hill, Pennsylvania. 1962–64. Window

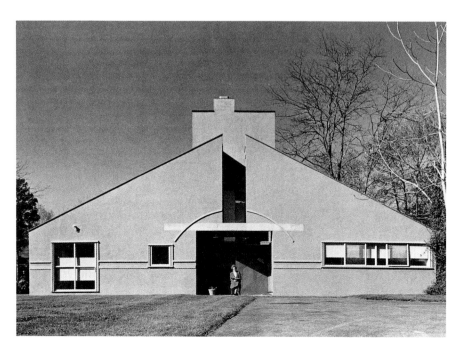

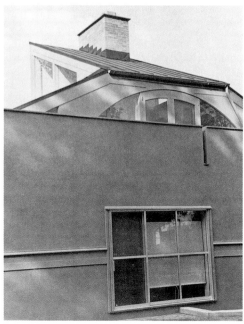

So, yes, you're right, the intellectual justification of these buildings came after they were designed.

Wrede: At the beginning, when you were designing Guild House, the whole thing was a kind of intuitive polemic?

Venturi: Yes, I think so. I did work that embodied certain ideas which, over time, became evident to me. I wrote my books to understand those ideas.

Wrede: In *Complexity and Contradiction,* you talk about Main Street being "almost all right," and that would seem to relate to the whole idea of Guild House.

Venturi: I think it relates to a reaction against the modernist progressive view that advocates total and universal reform of the urban landscape toward utopian goals, and promotes, instead, a reappraisal of what's there, and evolving realistically out of that and building on it in urbanism and architecture. It's funny that an example of that approach today might be Seaside, Florida, which is a manifestation of Main Street as "almost all right."

Wrede: But Seaside is a very nostalgic version.

Venturi: You're right. "Main Street is almost all right" is not only anti-utopian, but also anti-nostalgic.

Wrede: Let me go back to the sixties again. How was the book received when it first came out?

Venturi: It didn't make a big splash. But I do remember a wonderful negative response about that time toward the North Penn Visiting Nurses Headquarters of 1961 (fig. 15), which appears in the book. I had written a squib to accompany photographs I had submitted to *The Architectural Forum,* hoping it would be published. It *was* published with one little photograph in the news section at the beginning of the issue with a quotation from me that had evidently sounded pretentious to the editor; his response was, "But where does this kind of architecture go from here?"[18] Well, we all know the answer now.

Concerning the book there was not much acceptance and quite a lot of resistance. But Vince Scully liked it and promoted it, and so did Bob Stern. And the book sold relatively well — it's still in print. How much that is due to sentiment on the part of your institution, I don't know, but it is unusual for a book to be in print after so many years. And it has been translated into ten languages!

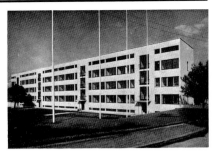

14. Ludwig Mies van der Rohe. Weissenhof-siedlung, Stuttgart. 1927

15. Venturi and Short. North Penn Visiting Nurses Association Headquarters, Ambler, Pennsylvania. 1961

Wrede: Do you remember a particular example of hostility toward the book?

Venturi: Steven Izenour recalls that when he was a student on a Fulbright Scholarship at the Royal Danish Academy of Architecture in the late sixties, he was called into the dean's office one day and instructed not to leave the book lying around the school!

There was a general hostility to our design, much of it stemming from the fact that our architecture is not easy to take. It's not overtly sensual. Our architecture is not a manifestation of our theories, but it parallels the theories and is not instantly likeable.

All during that period we were not well accepted and we did not get big commissions. On the other hand, there were always a number of people who admired us and respected us. They were a minority but they were there and we forever remember them. So I can feel somewhat paranoid but not terribly paranoid.

Wrede: How do you feel about the way things have changed, now that the ideas in the book are generally accepted?

Venturi: I think a lot of what goes for deconstructivism (fig. 16), among other things happening today, is a manifestation of the book. I think much of it *is Complexity and Contradiction,* with certain enormous ironies. To use the now old-fashioned modern vocabulary based on industrial elements in mannerist ways is combining mannerism and modernism to absurd degrees, almost oxymoronic: it's often like a Puritan lady doing the cancan — it's *crazy* mannerism! — an extreme form of what that book stood for. I think some of what's happening is an extremist and obscurantist manifestation of *Complexity and Contradiction.*

Wrede: It has occurred to me as well that the arguments advanced by the deconstructivists parallel arguments in *Complexity and Contradiction,* but are used, obviously, to justify other aesthetics.

Venturi: I'm more resentful now than I was before. I used to think, if my argument is not accepted, that's okay. Now, I think its message is a part of the ethos, accepted, and behind a lot of architecture today — in the work of many of those who disdain the book. And then there are those whose work derives from it, but who are not aware of that because the content of the book has become inherent in our ethos.

Wrede: This may be indirectly related. In your preface, you quote Henry-Russell Hitchcock:

16. Eisenman Robertson Architects. Project for Biocenter, University of Frankfurt. 1987. Study model A

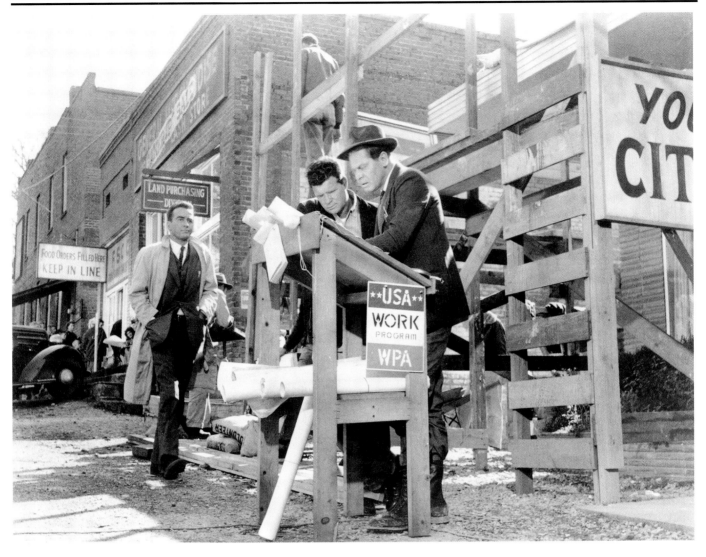

7. Montgomery Clift and Frank Overton (right) in *Wild River*. (All remaining illustrations are from the film)

committed liberal to this day. In *A Life,* he confessed to a conflict of feelings regarding *Wild River:*

In talking to him [Paul Osborn], I soon discovered an astonishing thing: I'd switched sides. I'd conceived of this film years before as an homage to the spirit of FDR; my hero was to be a resolute New Dealer engaged in the difficult task of convincing "reactionary" country people that it was necessary, in the name of the public good, for them to move off their land and allow themselves to be relocated. Now I found my sympathies were with the obdurate old lady who lived on the island . . . I was all for her. Something more than the shreds of my liberal ideology was at work now, something truer, perhaps, and certainly stronger. . . . The way the reversal in the film's central emotion was carried out illustrates how drastically a director can change the meaning of a story he's chosen to tell.[10]

What Kazan is getting at in this last sentence is illustrated in many works by one of his masters — John Ford. When Kazan speaks of "the film's

central emotion," he is suggesting a process whereby Ella Garth becomes a kind of icon, whereby she is mythologized. In Ford's *The Searchers* (1956), John Wayne's Ethan Edwards is a distinctly disagreeable man, cynical and overbearing (a character much like the one Ford himself affected in real life). On paper, the script is definitely stacked against him. Yet, in the film, thanks to Ford's direction and Wayne's emotionally complex and resonant performance, he emerges as a figure of heroic stature, evoking an intricate set of feelings.

Similarly, while our intellect, reflecting on the facts presented by the screenplay of *Wild River,* knows that Ella Garth is wrong, our heart is so moved by Jo Van Fleet's sympathetic embodiment of this narrow-minded old woman that we, too, wind up having "switched sides." Such is the mystic and mythic power of movies to pull us into their grasp. We are drawn to what our *feelings* tell us is authentic — Ethan Edwards, Ella Garth — to, as Kazan says, "something truer . . . and stronger."

Kazan, of course, had long since established himself as a first-rate director of actors on both stage and screen. What was different in *Wild River* was the lower key, the lack of even momentary histrionics, the simpler truth. What was different was the product of a maturation process that finally enabled him to transcend mere craftsmanship, and become an artist.

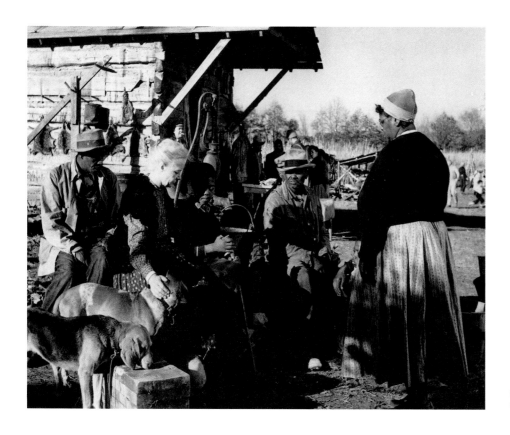

8. Jo Van Fleet as Ella Garth with the tenant farmers

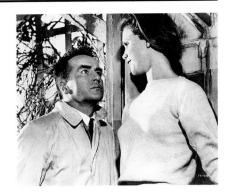

9. Montgomery Clift and Lee Remick

Direction, finally, is the exertion of your will over people.[11]

Wild River, like virtually all other sound films, started with a screenplay. It was written by Paul Osborn, a man of taste and competence. It is not the screenplay, however, which makes *Wild River* a special film.

When Robert Flaherty and F. W. Murnau had a falling-out during the preproduction period of *Tabu,* they agreed that Murnau would receive credit for directing the film, which turned out to be his last. Flaherty left the project, but he received screen credit for having "told" *Tabu.* In a variation on this, Kazan said in 1990, "The director *tells* the film, using a vocabulary the lesser part of which is an arrangement of words. . . . We learn to feel for the skeleton under the skin of words."[12] Citing Meyerhold as his mentor, Kazan goes on to say the director must "appreciate non-verbal possibilities" and know "that beneath the surface of his screenplay there is a subtext, a calendar of intentions and feelings and inner events."[13] It is, in part, the application of these principles which makes *Wild River* such an extraordinary experience.

Control is an important element in the art of film direction. The conventional wisdom is that greater control can be exercised in the artificial environment afforded by a studio, rather than submitting to the vagaries of a location. In the old days, wily directors like Ford and King Vidor had preferred location shooting as a simple means of evading control and interference by the producer. In the case of *Wild River,* Kazan, for only the second time in his career, was his own producer. (The first instance, *A Face in the Crowd,* 1957, whatever its virtues, might have benefited from some outside, moderating influence.) As both producer and director, Kazan could blame no one else for any of *Wild River*'s failings. As he says in his discourse "On What Makes a Director": "The final limitation and the most terrible one is limitation of his own talent."[14]

Elia Kazan was totally in control in the Tennessee countryside. He shaped this milieu brilliantly to capture the textures of this period and its people with his widescreen lens. There are, of course, the requisite superficial touches like FDR portraits and NRA signs. More important is the citizenry. The mayor, who doubles as the town barber, tells Glover that he cannot hire blacks for his project and, most certainly, not at the same wage as whites (a wage policy that, ironically, had changed little since Lincoln recruited freedmen for his Grand Army).

Ella Garth treats the blacks with maternalistic condescension, telling them they are free to get "relieved" by the government, if they see fit to leave her island domain. The choice is framed by her as having electricity put in place of their souls. Only Ben (played by Robert Earl Jones, father of James) is recognized by her as a figure of sufficient dignity and independence to be worthy of particular respect.

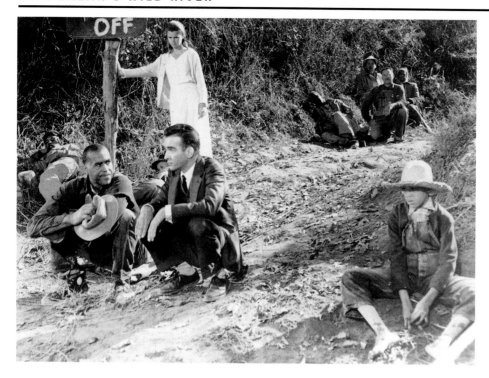

10. Robert Earl Jones, Lee Remick, and Montgomery Clift

If the black characters are pictured as abjectly ignorant, the peripheral white characters are also lacking in culture, as well as moral stature. Little old ladies sit around the hotel lobby and listen to the radio. The common men are rednecks, spoiling for a fight, and the self-designated responsible business leaders are blatant racists. Kazan knows and we know that time and the TVA will eventually change much of this, but his vision of 1934 Tennessee seems unflinchingly true.

Kazan, the actor become director, also understands that the most crucial test of a director's control of his medium turns on the performances he is able to coax out of those on the far side of the camera:

The director, that miserable son of a bitch. . . . There is something of himself, after all, in every character he properly creates. He understands people truly through understanding himself truly. . . . Some directors . . . still fear actors instead of embracing them as comrades in a task.[15]

Kazan has devoted a substantial part of his life to such coaxing and is most appreciative of the rare privileged moments acting can provide. Commenting on great performances that have lived on in his memory, Kazan suggests that these actors (Garbo, Brando, Walter Huston, Lee J. Cobb, and Takashi Shimura, among others) "gave you pieces of their lives. . . . You were the witness to a final intimacy . . . they gave you the genuine thing, the thing that hurt you as it thrilled you. . . . When that happens, your own life has grown."[16] In *Wild River,* Montgomery Clift, Jo Van Fleet, and Lee Remick each give us genuine "pieces of their lives."

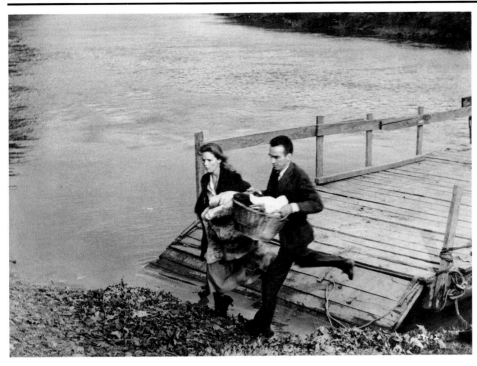

11. Montgomery Clift and Lee Remick

There are essentially two interwoven dramas in *Wild River* — Chuck Glover's efforts to remove Ella Garth from her island and the romance between Chuck and Ella's granddaughter, Carol (played by Remick). This second story has no real counterpart in either of the books on which Paul Osborn based his screenplay, and the story, as told by Kazan on screen, transcends Osborn's writing. It is arguably the best and most deeply felt work Elia Kazan has ever done.

Although there are visually stirring passages in *Wild River,* its greatest virtues spring from the fullest flowering of Kazan's outstanding gift of sensitivity to actors. His true *métier* is not spectacle in the Dovzhenko or John Ford sense, but the more intimate fireworks sparked by two souls adroitly rubbed together.

Sixteen years earlier, he had directed Montgomery Clift in the original stage production of Thornton Wilder's *The Skin of Our Teeth.* Kazan recalled him as an insecure boy who had temporarily adopted the director's wife, Molly Kazan, as a surrogate mother. In the intervening period, Clift had gone on to become a major romantic star, before suffering an automobile accident in 1957 which altered his appearance. Biographers have later revealed that Clift was gay and have also suggested feelings of sexual inadequacy which contributed to his alcoholism. By the time of *Wild River,* Kazan says, he "was a tenderhearted shell of a man" who "didn't look like Monty Clift anymore."[17]

In Clift's scenes with both Remick and Van Fleet, Kazan used his fragility ("the accident of personality")[18] to create a characterization rooted in vulnerability and tentative masculinity. As the director puts it: "Monty seemed sexu-

ally uncertain. He was."[19] Kazan had extracted from Clift a piece of his life.

Turning down for the part of Carol his former lover Marilyn Monroe, Kazan chose instead his discovery from *A Face in the Crowd* of three years earlier, Lee Remick. Possessing a quiescently lyrical beauty and a "confident sense of her own worth,"[20] Remick was perfect for the role of a sexually aggressive young widow and mother, striving for self-definition outside the sensibilities of Garth Island.

Remick's is a magnificent performance. Her Carol is appropriately devoid of glamor, but Remick had luminously sensual eyes. Kazan has his camera linger over them and the quivering textures of her face. She is subtly expressive of an almost animal sexual hunger barely held in check by a fear reflective of past pain and of that which is likely still to come. She accuses Chuck of being a romantic (he tells her not to marry a man she doesn't love), but she is the greatest romantic in Kazan's cinema. She knows that Chuck is there only for the business of removing Ella from the island, but her heart and her naked need will the relationship into reality. She is simple and direct, and her love is pure and without conditions.

Kazan lovingly photographs the sequence of Carol taking Chuck across the river, singing hauntingly, "And he walked with me, and he talked with me . . . the joy we shared, none other has ever known." With this as instrumental refrain on the soundtrack, she takes him to the cottage she briefly shared with her husband, its rooms now covered with faded leaves that have blown in through a broken window. It was here that she had a life and dignity of her own, free of Ella and her island. It was here that she had known love and pas-

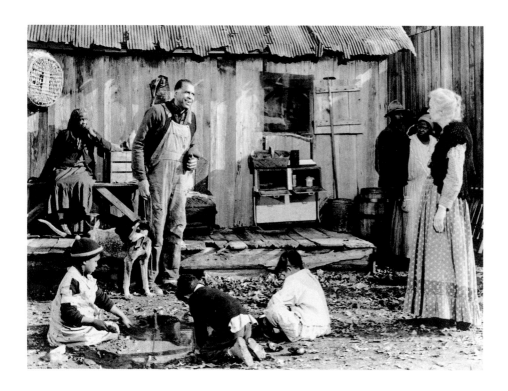

12. Robert Earl Jones and Jo Van Fleet

sion. It is here, now, that she seduces Chuck, and then returns alone to the island, singing as she ferries through the river's mist.

Kazan's cinema, famous for its grittiness and its *Sturm und Drang* of overstatement, has been transfigured for a few tender moments into a cinema of the most poignant and delicate poetry. At least one reel has been touched by the spirit of Renoir's *A Day in the Country* and Ford's *Young Mr. Lincoln*, and Lee Remick has given us a piece of her life.

Jo Van Fleet was only thirty-seven when she played the ancient Ella Garth. Kazan expresses his admiration for her submitting to the demands of the role:

Jo would barge into the makeup room at 4 a.m. and give five hours to transforming herself into an indomitable backwater matriarch. . . . She was the proof of the advantage of having a fine character actress much younger than the role she plays. Jo's emotions had the intensity that generally passes as youth passes.[21]

In the central, public drama of *Wild River,* Ella Garth's unyielding intensity overwhelms the polite hesitancy of Chuck Glover. While her granddaughter forces herself upon him physically, Ella holds Chuck at bay, displaying an acceptance of his humanity only after he shows up and passes out in the middle of a night of drunken desperation to which she has driven him: "First and only time I ever liked you." He wears a three-piece suit, symbol of authority and imposed order. Ella "likes things runnin' wild." He represents the TVA's intent to use "the tools of science," not just to change the course of the river, but to change the course of history. Ella "ain't a-goin' against nature."

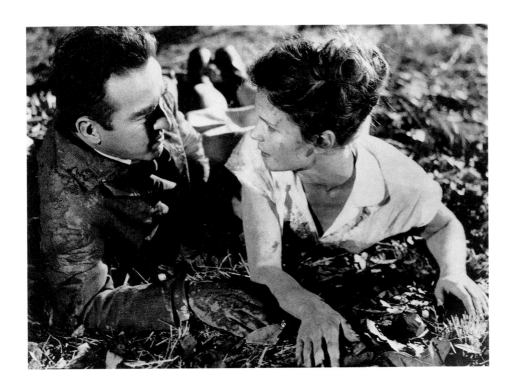

13. Montgomery Clift and Lee Remick

Finally, Washington directs Chuck to use force to evict Ella from the island that is her way of life. Ultimately, in spite of Chuck's efforts to conquer her will while still preserving her dignity, she triumphs over him and the TVA by willing her own death. She has given Carol sixteen cents to pay off a debt. "That's all I owe anybody!" Van Fleet's immutable stoicism on Ella's final day is extraordinarily poignant.

Kazan will not let Chuck or us off so easily. For Ella Garth, there is no shred of compromise. Van Fleet plays not for pity, but for respect. Her time is the past, but, as in John Ford, that time compares favorably with the present. She is not parted from the land for long. She is brought back to the island cemetery for burial, but, again as in Ford, the end of physical life is the beginning of life in memory. In Kazan's film, through Van Fleet's vivid performance, Ella survives as a richly delineated legend who hasn't sold her soul for electricity. She has denied and defied the TVA's "truth." As the film ends, Chuck and Carol and her children fly in a small plane over Ella's nearly submerged grave and then on over the great dam. Jo Van Fleet has also given us a piece of her life. As Huie envisioned Ella as "a great actress," Van Fleet, too, "had more fire and energy than ten average women, and she knew how to time an entrance," and her character's exit from life.

Critical reaction to *Wild River*, as was generally true of Kazan's films, flowed over a wide delta of opinion. Jonas Mekas, reviewing it on release, dismissed it as the director's "least successful" film to date.[22] With a quarter-century's hindsight, Dave Kehr called it Kazan's "finest and deepest film."[23] The only serious analysis of *Wild River* (in English) is by Michael Walker.[24]

For Elia Kazan himself it is a clear favorite, surpassed in his affection only by the intensely personal saga of his uncle's immigrant experience, *America, America* (1963).

Kazan had told it with pictures. He was fifty when he made *Wild River*; he is now eighty-two. There is a very real sense in which this film was central to a process within his mind comparable to Ella Garth's paying off "all I owe anybody." *Wild River* helped to liberate him as an artist and reach a stage of maturity where he felt less encumbered by the demands of others. A very healthy selfishness set in, and he began making films of his own choosing and under conditions of greater personal control. He became a successful novelist and wrote a superb and frank autobiography. His private life eventually became more settled, and he outlived most of his political enemies or rebuilt bridges to estranged friends. He appears to have achieved his own Garth Island, and, as he says at the end of *A Life*, "I'm happy — on the whole."[25]

14. The leveling of Garth Island

Wild River. 1960. Twentieth Century–Fox. Produced and Directed by Elia Kazan. Screenplay by Paul Osborn. Based on novels by William Bradford Huie and Borden Deal. Music composed and conducted by Kenyon Hopkins. Director of Photography (CinemaScope): Ellsworth Fredricks. Art Direction: Lyle R. Wheeler, Herman A. Blumenthal. Set Decoration: Walter M. Scott, Joseph Kish. Film Editor: William Reynolds. Costumes designed by Anna Hill Johnstone. Makeup by Ben Nye. Hair Styles by Helen Turpin. Assistant Director: Charles Maguire. Sound: Eugene Grossman, Richard Vorisek. Color by De Luxe. Color Consultant: Leonard Doss.

Cast: Montgomery Clift (Chuck Glover). Lee Remick (Carol). Jo Van Fleet (Ella Garth). Albert Salmi (Hank Bailey). J. C. Flippen (Hamilton Garth). James Westerfield (Cal Garth). Barbara Loden (Betsy Jackson). Frank Overton (Walter Clark). Malcolm Atterbury (Sy Moore). Robert Earl Jones (Ben). Bruce Dern (Jack Roper).

Synopsis

Wild River begins with a "newsreel" showing the devastation caused by the flooding Tennessee River. Chuck Glover (Montgomery Clift) is the third man sent by the Tennessee Valley Authority in Washington to persuade matriarch Ella Garth (Jo Van Fleet) to leave her island, which is soon to be flooded by a dam being built. He retains Betty Jackson (Barbara Loden) as his assistant, who, along with others, warns him of the difficulty of his task.

He visits Ella, is rebuffed by her, then thrown in the river by her sons. He returns to the island the next day and receives an apology and an explanation from Ella of her commitment to the land. Her granddaughter, Carol (Lee Remick), accompanies them to the cemetery where Carol's husband is buried. She goes back with him across the river and takes him to the cottage where she had lived with her husband and their two young children. There, she seduces Chuck.

Returning to his hotel, Chuck is beaten by Hank Bailey (Albert Salmi) for stirring up trouble in the community by offering jobs at equal pay to blacks. Chuck continues his romance with Carol and his unsuccessful efforts to persuade Ella. Walter Clark (Frank Overton), Carol's fiancé, tries to convince Chuck to leave, but the two men become wary friends, get drunk together, and then visit Ella in the middle of the night; Chuck passes out on Ella's doorstep.

As the TVA's efforts gain momentum, the offended townspeople finally corner Chuck, Carol, Walter, and the children in Carol's house. Forcing them outside, Bailey beats up both Chuck and Carol; as both of them lie in the mud, Chuck proposes to her.

The black tenants, except for loyal Ben (Robert Earl Jones), leave the island for new jobs, and Washington sends a federal marshal with Chuck to forcibly evict Ella. The Garth home is burned, and the island is leveled. Ella is taken to a new house on the mainland, but she refuses to enter. Soon afterward, sitting on the front porch, she dies. She is buried on the island.

Chuck, Carol, and the children fly over Ella's grave on what little of the island remains above water. Their plane takes them over the giant dam and then off to Washington.

Biographical Notes

Paul Osborn (1901–1988) had written plays produced on Broadway since 1928. These included *Mornings at Seven, On Borrowed Time,* and *The World of Suzie Wong.* He wrote screenplays for *Madame Curie* (1944), *The Yearling* (1946), *Portrait of Jennie* (1948), *Sayonara* (1957), *South Pacific* (1958), and Kazan's film of John Steinbeck's *East of Eden* (1955).

Montgomery Clift (1920–1966) had been directed by Kazan on the stage. His films include *The Search* (1948), *Red River* (1948), *The Heiress* (1949), *A Place in the Sun* (1951), *I Confess* (1953), *From Here to Eternity* (1953), *Raintree County* (1957), *The Young Lions* (1958), *Lonelyhearts* (1959), *Suddenly Last Summer* (1959), *The Misfits* (1960), *Judgment at Nuremberg* (1961), and *Freud* (1963).

Lee Remick (1935–1991) made her film debut in Kazan's *A Face in the Crowd* (1957). Her other films include *The Long Hot Summer* (1958), *Anatomy of a Murder* (1959), *Experiment in Terror* (1962), *Days of Wine and Roses* (1963), *Baby the Rain Must Fall* (1965), *Sometimes a Great Notion* (1972), *The Europeans* (1979), and *Tribute* (1980). She worked extensively in television.

Jo Van Fleet (b. 1922) had worked on Broadway for a decade before appearing in Kazan's *East of Eden* (1955), for which she received an Oscar as Best Supporting Actress. Her other films include *The Rose Tatoo* (1955), *I'll Cry Tomorrow* (1955), *Cool Hand Luke* (1967), and *The Tenant* (1976).

Barbara Loden (1932–1980) had been directed by Kazan in Arthur Miller's play *After the Fall,* and she also appears in Kazan's *Splendor in the Grass* (1961). They were married in 1967. In 1970, she directed a critically acclaimed film, *Wanda.* Kazan has said in "On What Makes a Director": "The painters of the Italian Renaissance used their mistresses as models for the Madonna, so who can blame a film director for using his girlfriend in a leading role — unless she does a bad job." And so he did, and she didn't.

Notes to the Text

1. See Erskine Caldwell and Margaret Bourke-White, *You Have Seen Their Faces* (New York: Modern Age Books, 1937); James Agee and Walker Evans, *Let Us Now Praise Famous Men* (Boston: Houghton Mifflin Co., 1941); and Eudora Welty, *Photographs* (Jackson, Miss.: University Press of Mississippi, 1989).

2. William Bradford Huie, *Mud on the Stars* (New York: L. B. Fischer, 1942); and Borden Deal, *Dunbar's Cove* (New York: Charles Scribner's Sons, 1957).

3. Elia Kazan, "On What Makes a Director," *DGA Newsletter,* January 1990, p. 9.

4. Elia Kazan, "A Natural Phenomenon" (interview with Michel Delahaye), *Cahiers-du-cinéma in English,* no. 9 (March 1967), p. 34.

5. Elia Kazan, *A Life* (New York: Alfred A. Knopf, 1988), p. 600.

6. Ibid., pp. 254–55.

7. Kazan, "A Natural Phenomenon," p. 34.

9. Robin Wood, "The Kazan Problem," *Movie,* no. 19 (Winter 1971–72), p. 31.

10. Kazan, *A Life,* pp. 596–97.

11. Kazan, "On What Makes a Director," p. 11.

12. Ibid., p. 6.

13. Ibid.

14. Ibid., p. 12.

15. Ibid., pp. 9–12.

16. Kazan, *A Life,* p. 146.

17. Ibid., pp. 597–98.

18. Ibid., p. 599.

19. Ibid.

20. Ibid.

21. Ibid., p. 598.

22. Jonas Mekas, "Movie Journal," *The Village Voice,* June 1, 1960.

23. Dave Kehr, "Critics Choice: *Wild River,*" *The Los Angeles Reader,* January 27, 1984, p. 37.

24. Michael Walker, "Wild River," *Movie,* no. 19 (Winter 1971–72), pp. 24–28.

25. Kazan, *A Life,* p. 825.

Contributors

John Elderfield is Director of the Department of Drawings,
Curator in the Department of Painting and Sculpture, and
Editor of *Studies in Modern Art.*

Rosalind Krauss was recently appointed Professor of Art History
at Columbia University.

Joseph Ruzicka is Research Coordinator for *Studies in Modern Art.*

Charles Silver is Supervisor of the Museum's Film Study Center.

Robert Venturi is a principal in the architectural firm of Venturi,
Scott Brown and Associates, in Philadelphia.

Wendy Weitman is Associate Curator in the Department of Prints
and Illustrated Books.

Stuart Wrede is Director of the Department of Architecture and Design.

Lynn Zelevansky is Curatorial Assistant in the Department of Painting
and Sculpture.